PAINTING ABSTRACT PICTURES

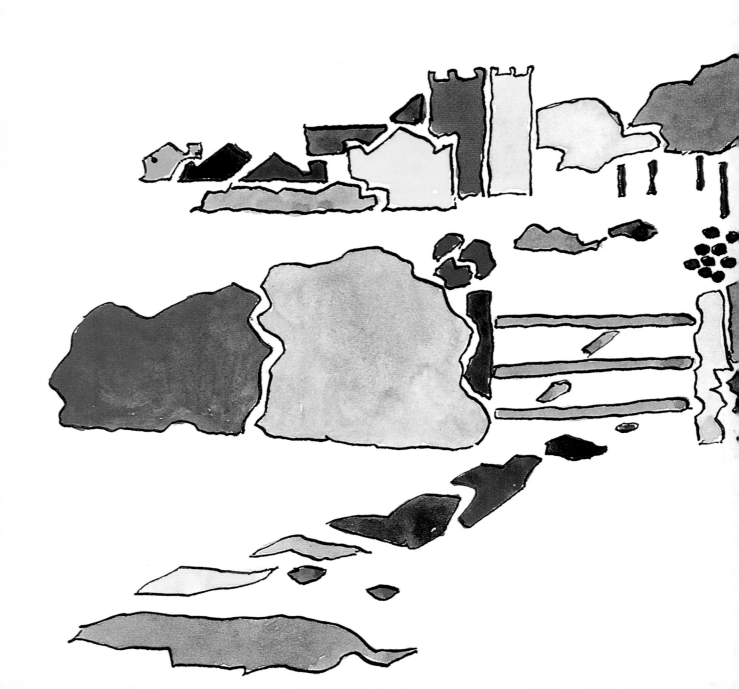

PAINTING ABSTRACT PICTURES

RONALD PEARSALL

DAVID & CHARLES
Newton Abbot London

Frontispiece:
A Cornish landscape in abstract terms. This kind of subject can be added to at will. Newcomers to abstract painting may prefer to start off with something where there is an element of representation

British Library Cataloguing in Publication Data
Pearsall, Ronald
 Painting abstract pictures.
 1. abstract paintings. Techniques
 I. Title
 753'.5

 ISBN 0–7153–9460–6

Typeset and designed by John Youé
on a Macintosh system.
Printed in Singapore by C.S.Graphics Pte. Ltd
for David & Charles plc
Brunel House Newton Abbot Devon

CONTENTS

INTRODUCTION

This is a practical book for people who think independently and are not overawed by the idea of abstract pictures or the prospect of painting them.

The word abstract itself can have all kinds of meaning, but generally is a convenient term for non-representational pictures. There are two main types of abstract picture – those which are sparked off by elements in the outside world and contain references to these, and those which are not. Most typical of the last group is geometric abstraction, combining coloured shapes.

Why do people paint abstract pictures? For much the same reasons as people paint pictures of birds, landscapes, fantasy scenes, or cityscapes – because they like doing it; because it suits their temperament. An abstract painting can be spontaneous, a continuous work-in-progress with the artist having no idea how it is going to finish up. This is not something new. Artists of the past put a few splashes of colour on their paper and waited to see what these suggested. Or the painting can be fully worked out. It is up to you. There are no rules; if there are any, you make them.

The aim of this book is to encourage readers to jump in at the deep end, whether they can draw a dog that looks like a dog or not. Hopefully it will encourage experiment, in the use of colours and colour combinations, in the use of shapes, in turning doodles into works of art.

Abstract art does not have to be 'like'. It may incorporate echoes of everyday life, or it can be pure design, pattern-making; it can be coldly objective or personal – or life-enhancing as you explore the magic world of shape and colour. It can be set out with mathematical precision, or as off-beat as you wish.

Abstract paintings can be done in any traditional medium – oils, watercolours, pastel, acrylic – and on almost any surface. Preparation, materials and techniques will all be fully discussed, and the accent throughout will be on adventure and enjoyment.

Abstract painting is a modern art for a modern age. If a picture is seen just as an element in the interior décor, so be it: there is no reason why a painting should not match an interior along with curtains or wallpaper, nothing to stop an abstract painting meaning something or nothing. Nor is there anything unusual about painting non-representational pictures. If you look at the history of man from earliest times, you may conclude that there is something odd in painting representational pictures!

Above right:
A collage by Roy Ray (born 1936), one of the most important West Country non-representational artists. In his work there is often a suggestion of an aerial or bird's-eye view of his adopted county, Cornwall. This work is made up of hand-coloured tissue paper and acrylic washes on canvas

Right:
An abstract picture need not have any reference to anything in the outside world, but be purely shapes and colour. Nor need it be painted. This is a collage using coloured adhesive paper

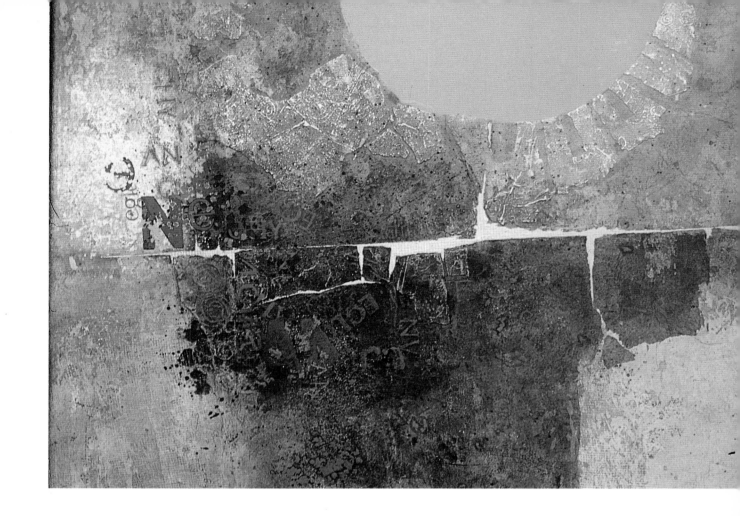

ENJOYING ABSTRACT PAINTINGS

Enjoyment is somehow different to understanding and appreciation. Almost anything can be understood if sufficient time is devoted to the task, though there may be no pleasure involved. Appreciation is a step nearer, but there is a coolness about the word, savouring of wandering around vast galleries being informed for the good of your soul. Enjoyment is personal; it is not pushed on you by others who think that they know better. And enjoyment is the essence of this book – pleasure in creating something, pleasure in looking at something to which you may not have paid more than a passing glance before.

Abstract painting may not be to everyone's taste, but more people are aware of it and like it than they realise, for its effect is evident all around us: in advertisements in newspapers and magazines – a long tradition dating back to the

1920s and 1930s, when fine artists with a taste for non-representational work were employed by far-sighted organisations such as London Underground; in the shape of office and kitchen equipment – the ordinary pen-tidy can be a miniature abstract sculpture; and in buildings. Look at a modern office block, often containing contrasting geometric shapes in black and window glass – it is almost as if an abstract painting has been created on a massive scale. A good example is the old *Daily Express* office in Fleet Street dating from 1930, inconceivable without

A 1920s advertisement which is almost an abstract picture in its own right

what has been called the modern movement.

Of course there are all kinds of abstract paintings, and some you will like more than others. Some you will positively detest, though after a time you may begin to see the point of them – and if you don't, it doesn't matter. Art critics react in the same way; but if they don't like it, their observations are sometimes remarkably crass and irrelevant compared with the viewpoint of a person who knows what he or she likes and doesn't mind admitting it.

Being a 'good' abstract artist means being perhaps startlingly original, a superb craftsman, or maybe a painter of superb taste and refinement; and every good artist has had imitators who have used the techniques with a good deal of skill, but have somehow not hit the top notes. This doesn't mean to say that their works are no good; they may even appeal to you more than those of the so-called masters, in that they make what can be austere disciplines more homely and acceptable. The game of dividing pictures into the best, the second rank, and the also-rans has been played out.

As mentioned already, there are several categories of abstract art – the geometric, the organic, and the hell-for-leather. Sometimes these categories merge, and sometimes the artists enjoy a playful game bamboozling the eye – a practice that has been carried out for centuries, and one that will continue whatever art styles form in the future.

Natural forms, such as a flower, can suggest an abstract picture. It can start off simply, such as this

Perhaps you like an arrangement of colours and shapes. They don't have to mean anything, even if they do bear a title. They may remind you of a place, even of a sensation – or perhaps of music, for there is a strong connection between abstract art and music as both appeal to the part of the mind that is not concerned with the day-to-day business of living. Several artists have tried to voice this, though often they get bogged down in the problem of explaining something in terms

• •

Prices obtained at auction for works of art are staggering, and nowhere more so than in the field of abstract paintings. In November 1988 there was a sale of contemporary American art at Christie's in New York, and much of this art was abstract. After World War II abstract painting flourished in the United States, as it did in Paris, many of the French artists carrying on the traditions of Braque, Picasso and old-style Cubism. American abstract painting was adventurous, startling, and the cause of much gnashing of teeth by those who had not so much been left behind but had travelled a different road altogether.

At the time it was thought by many eminent critics that the American artists were poseurs interested only in self-advertisement and being different. But

posterity will always tell – and it has to a certain degree, for look at the outcome now that more than thirty years have gone by. Jasper Johns, for example, who specialised in painting American flags, over and over again. No-one disputed that the paint was put on well and that Johns was a true artist, but it was thought he was perhaps cultivating his own little patch rather too strenuously – one American flag is all right but a dozen more hints at replication.

White Flag was one of a series painted in the 1950s. The red and blue colours were not seen, only wax paint the colour and texture of porridge. It was first bought by a collector while it was still unfinished on the easel: it was a good buy, for in November 1988 it sold for £3,911,111.

• •

of something else – much as the physicist when faced with the difficulty of explaining symbols and equations in ordinary language.

One of the surest tests is whether you could live with the picture: could you bear to put it on the wall and see it day after day? Do you think you would see more in it after a time? It may be something extremely uncomplicated, such as Malevich's white square on a white background; you may find it so utterly restful that it will always be a solace when things go wrong, simply by virtue of its extreme simplicity – somehow Malevich was saying something that you vaguely understand. Or it may be a picture that is full of motion, such as one of Jackson Pollock's hectic Action Paintings, where you can identify with the artist pouring out his innermost emotions in flur- ries, whirls, and great globules of paint. In such a painting you may see half-hidden images, as you do when looking into a fire, images that are nothing to do with the artist but all to do with you; in fact, you are creating your own picture as you watch.

Every person sees a picture differently, though it may be only a subtle difference impossible to define. For example, one viewer can look at a Cubist picture by Braque or by Picasso, and even with the help of a usually explicit title such as *Man*

● ●

The streaks and splashes and rivulets of screaming colour of abstract expressionism were also not to everyone's taste in the 1940s and 1950s. The key painter of this school was Jackson Pollock: his *Frieze* of 1953-5 sold at the same sale for £3,177,777. Mark Rothko was more restrained. He was into blurred shapes without outlines – it was said that such pictures could be painted in twenty minutes and still leave time for a cup of coffee. Nevertheless, one of his pictures painted in about 1952 sold for £1,527,777.
Many of these artists painted on a huge scale, as though a simple shape ten feet tall was more significant than one a foot tall. But it has paid off. Another of the American school, Franz Kline, did a massive painting in black and white which he called *Lehigh*, from the name of a coal town in Pennsylvania. It is not known whether this fact contributed towards the £1,283,333 it obtained at Christie's, New York.
Readers, search through your attics. You never know!

● ●

with a Pipe, cannot make head nor tail of it at all. Whereas another person can pick out all the clues and references without needing to be told, even though he or she may never have looked at a Cubist picture before. Sometimes even artists are not aware of what they are doing; they only know that they have to paint a picture a certain way. They have no conscious colour schemes; the colours on their canvas just arrive. Some- times, however, they are fully aware: their pic- tures have been thought about, the elements have been balanced with mathematical skill. Will this circle match this rectangle? Is this particular colour too strong? Will this patch of black take the eye out of the picture?

Abstract painting embraces such a wide field that there is room for all artists of all calibres. Some are only interested in making decorations, finding joy in arranging shapes and colours, knowing that someone else will like them too. Others are intent on exploring the nature of things, creating visual equivalents of almost anything – moods, half-remembered dreams, sensations that are on the borderland of exis- tence. Sometimes these can be abstruse; and sometimes they are of no interest at all except to the artist, and unless the artist is known person- ally these feelings mean nothing. But at some time, even faced with the most unrewarding picture, something is bound to stir, and you may experience something of what the artist felt, a kind of telepathy sparked off by taking in the picture and exploring it.

Abstract painting is one of the oldest kinds of art, and should not be found alarming. Images in prehistoric times were made for magical pur- poses and were not necessarily realistic images,

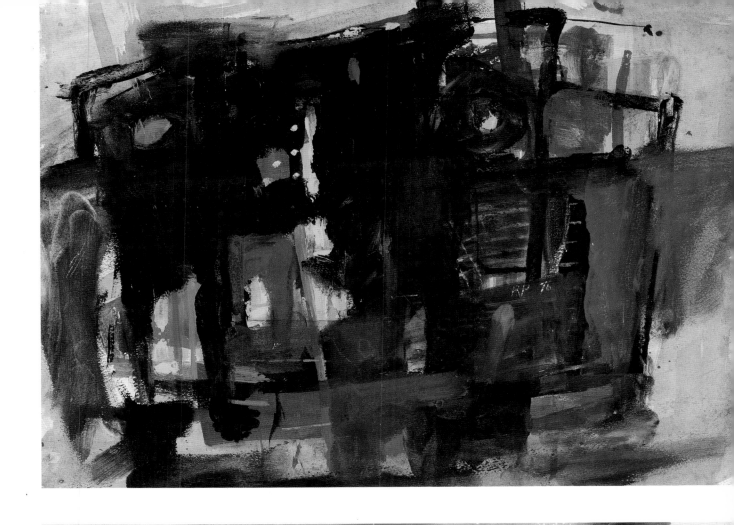

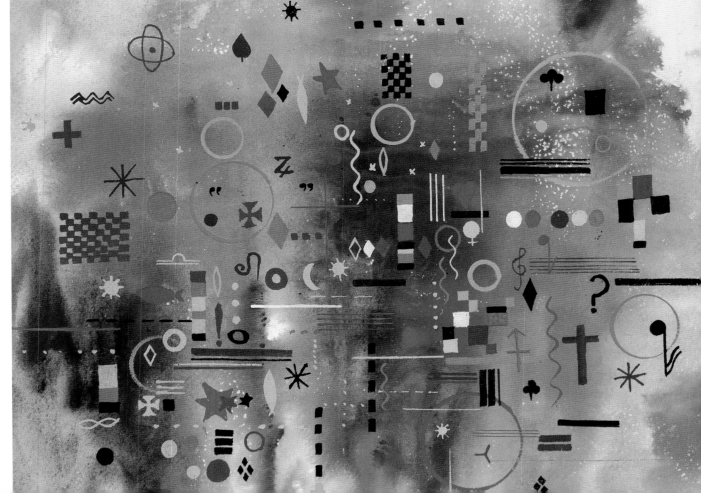

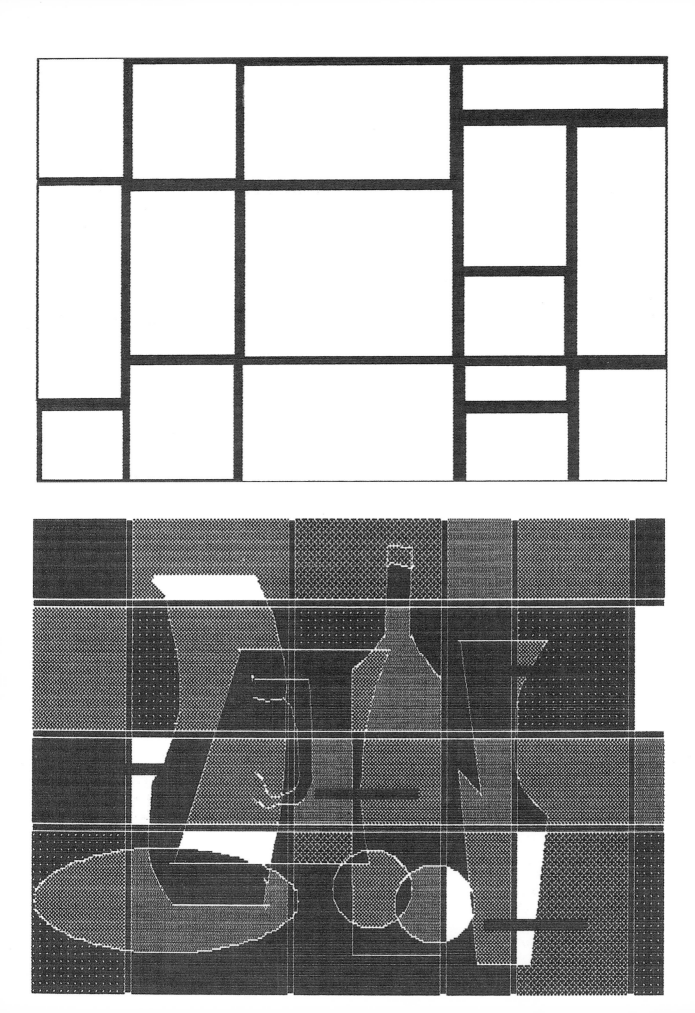

just shapes. An abstract painting is not trying to be 'like' something, it is there in its own right. It is an object in space, and you can take it or leave it; once the artist has created it, he then has nothing to do with it. He may be an artist whose work fetches millions, such as Pollock; or he may be some young man who can't afford canvas and uses cardboard from boxes thrown out by the local supermarket. But he may have produced something – probably without knowing how he did it – which has something specific to say to you. Colours and shapes are universal so there is no language problem, and the seeds of modern abstract painting were sown in what might seem barren ground – Russia in the chaos of the Revolution, Holland, and Italy with its ancient and noble painting traditions. In Britain there was – and is still – a marvellous bastion of abstract painting in Cornwall.

In so much abstract painting the joy in painting is self-evident, and can be clearly seen by looking closely at the brush strokes: sometimes the paint has a beautiful enamelled quality, sometimes the gestures are broad and impulsive, shape overlapping shape, the artist not interested in tidying it up and making it neat. Then with painters such as de Stäel we have luscious paint laid on with a palette knife; with others, especially the French artists who worked in the 1940s and 1950s, refined rectangles of advancing and receding colours, so precisely placed. These were not artists who could not do anything else; they were artists in the great Paris tradition, turning their attention to a form of art that captivated them. And fortunately their paintings captivated the collectors too, and made their creators a living.

Enjoying looking at abstracts is one thing; painting them, however, is another and you are in a different world, a doer not a looker.

Above:
A realistic drawing with an abstract equivalent, demonstrating how real life can be a starting-point towards adventure

● ●

The abstract artist starts off with the intention of satisfying himself, but being of an intellectual turn of mind, he can find no form in nature adequately suited to his purpose. He therefore invents and places on canvas forms of his own. The result of his labours may or may not be a work of art; we cannot tell, simply because we have no past experience upon which to base our judgment of it, so that the abstract painting today is more or less a self-imposed problem which the artist brings to some logical conclusion.

Francis G. Conway 1934

● ●

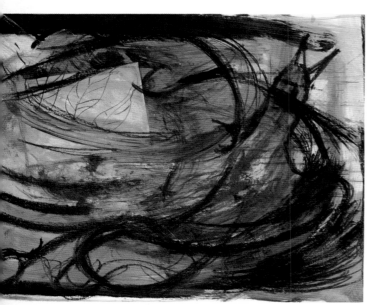

Above:
This painting by the talented David Pearce is entitled Sunset. David Pearce is not concerned with the external appearance of things, but seeks to make a visual equivalent. He has evolved his own techniques using a basis of plaster-of-Paris and white emulsion. He subjects his work to what he calls sand-blasting, which involves taking his paintings to the beach and letting wind and sand texture the pictures

Left:
A painting by the now-established artist Rebecca Roberts, in which there is confidence and assurance in the swirling forms. Rebecca Roberts studied at Falmouth School of Art for five years, and her work is never purely abstract but has a reference to the outside world

Left:
An abstract painting can be uncomplicated, relying on the placing of accents of colour on a flat background. This is called Pond Forms and is acrylic and pen and ink on coloured paper

Right:
Composition Blue by Natalia Dumitresco, dated1960, and of considerable size (146x114cm). As with many contemporary abstract paintings, there is a sense of aerial photography. This picture was exhibited by the Zemmer Gallery in London, and sold later by Phillips of New Bond Street

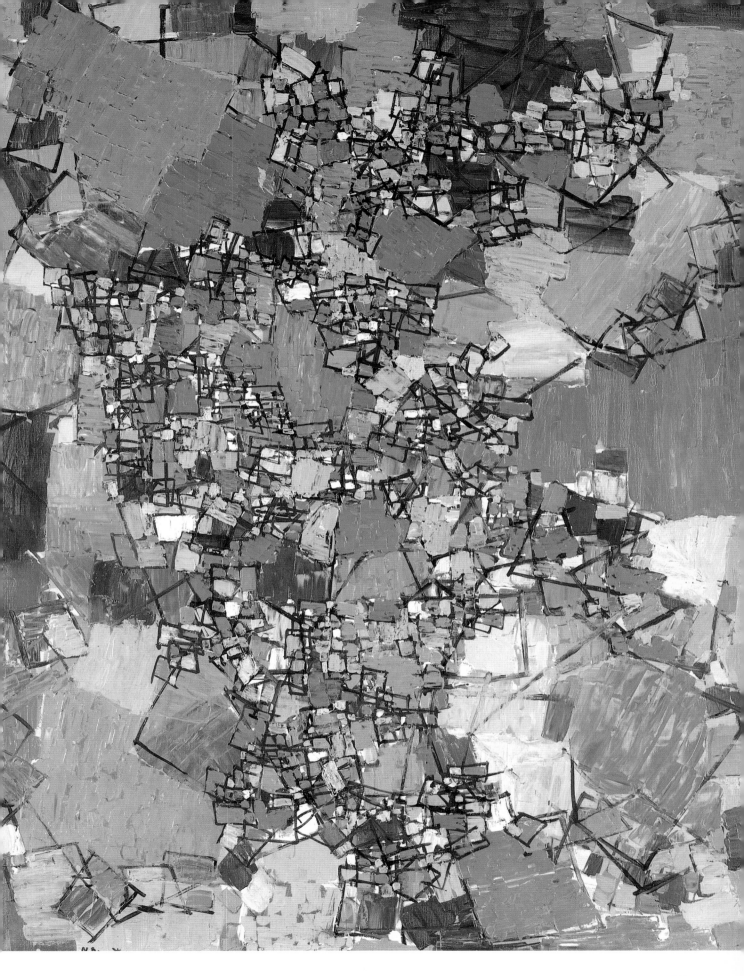

HISTORY OF ABSTRACT PAINTING

The background of abstract art is really quite simple, and its development fairly obvious. In the nineteenth century, painting – helped by photography – had reached a pitch of perfection and anything 'out there' could be painted. If you wanted a detailed scene of everyday life, you went to Frith; if you wanted luscious pin-up nudes, you went to Lord Leighton; if you wanted marble so life-like that you could almost touch it, you went to Alma-Tadema. Artists then sought to express qualities other than likeness – solidity (Cézanne), the effects of light (Impressionism), novel painting techniques (Seurat) – and also began to interpret what they saw. Some of them merely manipulated images, others transformed, but the two real pioneers were Braque and Picasso who in the early years of this century created Cubism; they were, wrote Braque, 'like two mountaineers roped together'.

They took still life as their starting point, often with added figures, and the subjects were depicted in shapes, lines, and planes. Sometimes the content of the picture is self-evident, sometimes it needs deciphering: it can be a series of overlapping segments with merely a hint of reality – perhaps a man's pipe, perhaps the strings of a guitar – or the items can be spread over the picture surface so that it is easy to read them off. The time was right for such experiment, and Paris was the place to be.

Cubism offered freedom – freedom from the ancient need to imitate reality, freedom to find new means of expression. Cubism could express what the artist felt about something, wringing it out and finding the essence, or it could be pattern-making. New techniques were evolved. In 1912 Picasso used a piece of printed oil-cloth for a section of his picture *Still Life with Chair Caning*, and in the same year Braque used wallpaper

imitating wood panels – in 1913 he used a decorator's comb to reproduce the grain of wood in another picture. Both artists were playing with reality; they were creating their own kind of space, mixing visual information in a grand game – and as it was Paris and not London they were treated seriously, as adventurers in a new world and not as jokers or freaks.

A key feature of Cubism was the preference for geometric shapes and straight lines, and it was not long before paintings were produced in which the subjects themselves consisted of such shapes and the general hard-edge of Cubism, based on

nothing but themselves – so a circular shape was no longer an apple, but a circular shape. An early work of pure abstraction – despite a picturesque title – was Robert Delaunay's *Window on the City* (1913). But Cubism did not have to be flat; Léger used curved planes to suggest volume against a two-dimensional background.

In the hands of representational painters, Cubism became a tool. The horrors of World War I were depicted in stylised terms by the English painters Nevinson and Paul Nash, who were far from being Cubists although they used the formula. To some, Cubism was the road to complete abstraction and it was followed by many, in particular the Dutchman Piet Mondrian whose paintings became overwhelmingly coloured rectangles intersected with black lines. This he called Neo-Plasticism, and if there is one

• •

Shall painting be confined to the sordid drudgery of facsimile representation of merely mortal and perishing substances, and not be, as poetry and music are, elevated to its own proper sphere of invention and visionary conception?

William Blake (1757-1827)

• •

Cubism can be 'a series of overlapping segments with merely a hint of reality'

Above:
A Cubist painting Figure en Mouvement
by Gustav Buchet, a minor figure, which sold in
1988 for £26,000 at Sotheby's. We are on the
borderline between representational and abstract
art and sometimes it is difficult to differentiate.
Not that it matters

Above right:
The same painting with alterations by the author.
How does this affect the painting? Is it a worse
painting? Would it reduce the value from £26,000 to
say £20 (the cost of the canvas and the paint)?
Of course, no-one would play around in this manner
with the actual painting. But the question is raised
about the qualities that make a picture important.
It is a question that has been asked a thousand
times over the last hundred years – but not very
often before then. With abstract pictures that
do not depend on traditional techniques – except
for laying down paint in a capable manner –
the question is even more difficult to answer

undisputed master of pure geometric abstract art
it is Mondrian.

Cubism and the early flowerings of abstract art
were international, and exhibitions, books and
magazines spread the message. In Russia,
Kasimir Malevich carried abstract art to its ulti-
mate and, as is always the case, gave his particu-
lar style of painting a name – Suprematism. The
first major product of this movement was a paint-
ing of a black square in the centre of a white
square, and this became the design on his tomb-
stone when he died in 1935.

All these artists were making points about re-
ality, but that hardly matters. No-one cares that
Mondrian was a theosophist, and that through his
paintings he was making quasi-ecclesiastical
statements: essentially, abstract pictures have to
stand up for themselves. Some are starkly im-
pressive, and some are bewitching, illustrating
the communicative powers of colours and shape;
others are tangled and complex, such as those
by Kandinsky who wrote that painting could
'develop the same energies as music' – painting
should penetrate the viewer and move him or her
as music does; and from 1909, Kandinsky termed
some of his paintings *Improvisations*. They are
cryptic; there are oblique references to real ob-
jects, but they are set in a tumult, as though

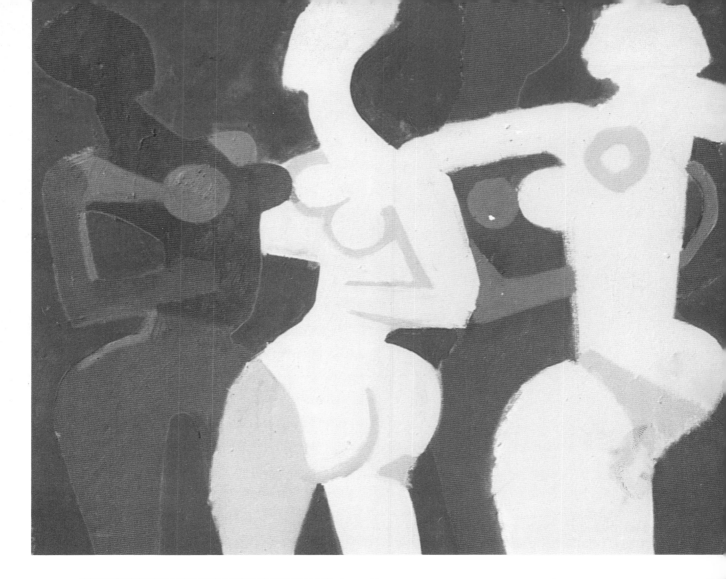

Above:
Many fine artists of today use the techniques developed in the Cubist period but in their own individual manner. This painting, Disco, is by Sam Dodwell RI, rich in movement and full of vigorous paintwork

Right:
A painting in the early manner of Malevich before he ventured into the kind of painting he is renowned for – pure geometry

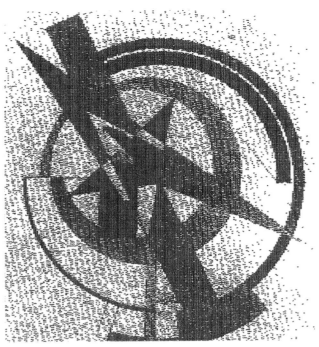

A Russian abstract watercolour painting from the 1920s, Wedge with Red Square *by El Lissitzky, a leading figure in what is known as the Suprematist movement, which sold in 1988 for £30,000*

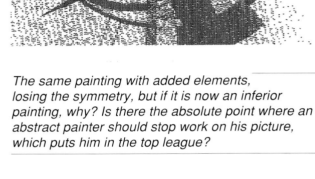

The same painting with added elements, losing the symmetry, but if it is now an inferior painting, why? Is there the absolute point where an abstract painter should stop work on his picture, which puts him in the top league?

revolving in space, sometimes exploding. Some abstract paintings are still and serene, but Kandinsky's early work is full of action and motion, with references to Russian folk art. In 1917, after the Russian Revolution, Kandinsky was given an important place in the Russian hierarchy and came under the influence of Malevich and geometric abstraction. His pictures changed. They, too, became geometric but rich in colour, seductive, downright pretty – and none the worse for that. He is another of the major abstract painters, a true pioneer.

Some of the best abstract painters, such as Gris, were not innovatory; they used what was there, adapting and developing, producing work of great refinement and beauty. Many artists went through an abstract phase, painting splendid pictures and then moving on, finding that it was not their style of thing. Some, such as Victor Pasmore spent much of their working life painting representational pictures of the highest quality before throwing it all up in favour of abstraction. Who knows why? Certainly abstract painting appeals to some more than to others, and seems to have nothing to do with ability – but all to do with a way of looking at things, and

looking into oneself, deciding what are the important factors of life; creating harmony, expressing a central idea, even preferring the inner world to the outer?

Some artists used abstraction and formalisation (simplification and ordering) to express their belief in progress and in mechanisation, their vision of the beauty of the machine age and all its artefacts, evoking rhythmic movement. This was the Futurist movement which had its stronghold in Italy, though its influence swept right through Europe; it had one very talented British disciple, Wyndham Lewis.

Others found that they could not express themselves in paint on canvas but instead made models, often from steel and aluminium but otherwise from almost any material; some of these were strung on wires and were later called mobiles. In the Russia of the early 1920s abstraction was a way of life, and was used in building projects, books, posters, theatre design and the cinema. This was Constructivism which spread gradually to western Europe, and together with other movements it had an immense effect on all aspects of life: the end result was Art Deco,

• •

It is perfectly obvious that an infinite number of nuances can exist in abstract symbols, a diversity as capricious yet as microcosmically ordered as the tiniest detail in nature. Those who have eyes will see – but you cannot get blood from a stone, and one cannot develop sensibility in others. Artistic appreciation is a physiological fact – you either have it or you have not.

W.E.Wright 1934

• •

Below:
Abstract painting has 'all to do with a way of looking at things'. This is a view, not everybody's, of suburbia

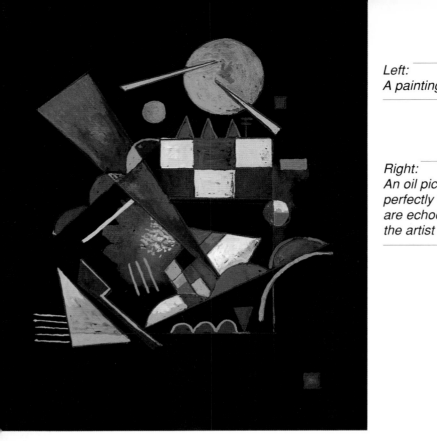

packaged abstraction for everyman. It is salutary
to think that without Constructivism and geome-
try-in-action we would not have had tower blocks.
All ideas and ideals become tainted if the wrong
people get hold of them.

Many artists in Britain and America were influ-
enced by the new wave in Europe; the future
career of Ben Nicholson was determined by his
seeing a Picasso picture. Rather surprisingly,
abstract art flourished in Britain, despite the
huffing and puffing of the old régime. Some of it
was interior decoration and some of it was rather
self-conscious, but it certainly has its charm. This
can hardly be said of the explosion of abstract
painting in America, which was totally dissimilar
to anything done before.

Many European artists spent World War II in
America. Paris ceased to be the centre of the
world art scene, even though marvellous artists
had continued to work there throughout the
occupation. Abstract Expressionism was New-
York generated: the artists were motivated by
resistance to materialism and the social system,
and turned their backs on stylishness and
form. They went – as one artist, Motherwell, put it
– 'voyaging into the night, one knows not where'.
Their state of mind was all-important; self-ex-
pression was the god. The act of painting was
sacred: the finished product was neither here nor
there. In 1947 Jackson Pollock exhibited his drip

paintings. They were large, and in construction
were placed on the floor while paint was dribbled
from cans or poked about with a stick, and it was
the actions produced whilst painting which were
incomparably significant. Thus the first name for
these pictures – Action Painting – was bestowed
in 1952.

Such paintings could be produced by bicycling
across the paint, bursting paint-filled bladders, or
having nubile, naked young women roll around
on the canvas. There is obviously no subject in
these pictures, no colour scheme, no design.
However, images were gradually introduced to
Abstract Expressionism by de Kooning; great
blotches of congealed paint gave way to light
paint fleetingly applied; a saturated canvas was
no longer a necessity. It could be a stark black
shape on a white ground, influenced by Oriental
calligraphy, as practised by Franz Kline (and
several artists in France, now mostly unknown
and consigned to the footnotes of art history).
Sublimity was very much an in-word. Could it be
achieved by having three coloured rectangles
hovering above each other, all a little woolly and
vague? Thus Mark Rothko's paintings, 1947-50.

It is a world away from Cubism and the well-
crafted picture, and opened the door to the in-
competent and self-important, for whom obscu-
rity is all. It was extremist art, and this was proudly
vaunted. But it led full circle to paintings covered

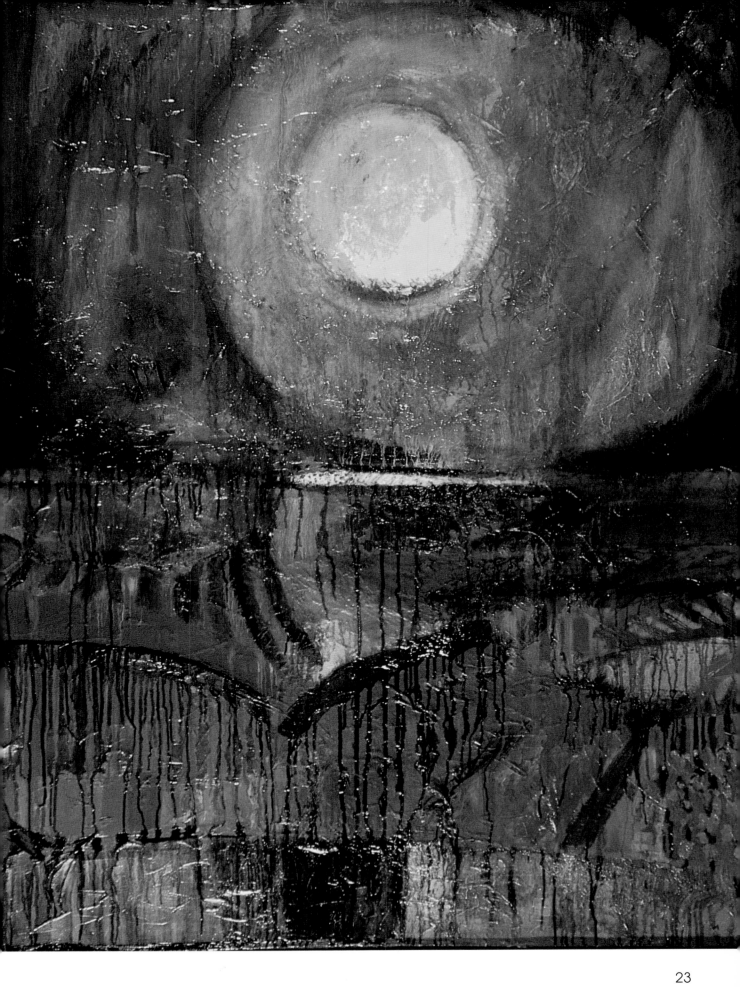

all over with one colour, beautifully applied, severely minimalist. Malevich would have understood it; he had done it a generation earlier. And geometric abstraction came back into vogue (it had not really gone away), often on oddly shaped canvases such as triangular and zigzag.

Among the most important of the post-war abstract painters was Nicolas de Stäel, who would use a palette knife to put luscious ragged-edged rectangles and other simple shapes in a harmonious and vibrant setting, emphasising that vehemence was not a prerequisite of up-to-

date painting. He was typical of many French-based artists who carried on the traditional abstract styles, unaffected by yet more movements to fill vacuums, such as Pop Art, where abstract-painting techniques were employed; as they were in Op Art where arrangements of colour were used to dazzle and confuse the eye so much so that looking at a painting of this kind is often a painful process: and surely, this is not what art is about.

Many of the labels that have been given to abstract art movements have been confusing. In practice, abstract art can be divided into three basic kinds: the geometric; the organic; and the inconsequential, where the result is a consequence of the activity of painting. The motives of the artists are manifold. Some are trying out their skills in making an object of taste that can be lived with; some are striving to deliver to a perplexed audience some notion of their inner turmoil; some are making a statement of their beliefs, creating a visual equivalent to their thoughts.

The reader can do likewise, though his or her work may not have a retail value of a few million dollars. Not yet, anyway.

• •

To me, abstract art looks like applied art which has lost its way, or a technique with the pretentions of an absolute, but I see no reason to quarrel about it so long as we are not all told that the spirit of our time necessitates painting in this way.

R.W. Alton 1934

• •

Right:
An abstract painting 'in space', using overlapping planes and vertical strokes (applied with the side of a palette knife) to get a sense of perspective. The upright strokes are clearly 'in front' of the rest of the picture

Below:
Russia 1917, *acrylic on paper: a kind of homage to the artistic spirit that arose after the Russian Revolution and in due course was dampened down, or, if we are thinking of spirits in another sense, diluted*

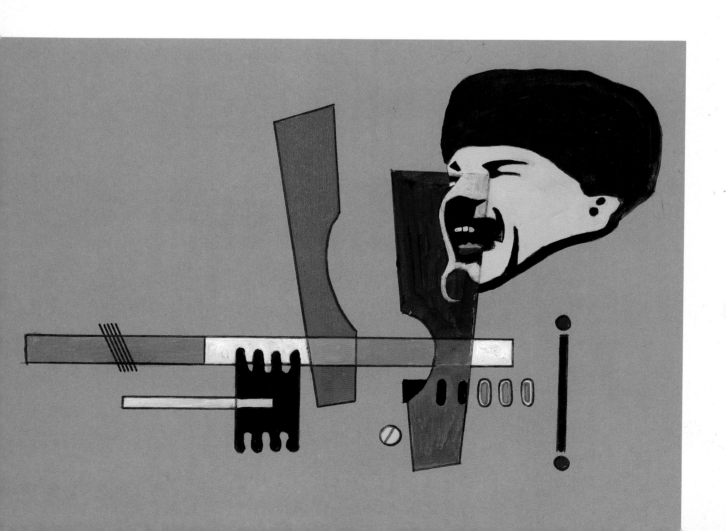

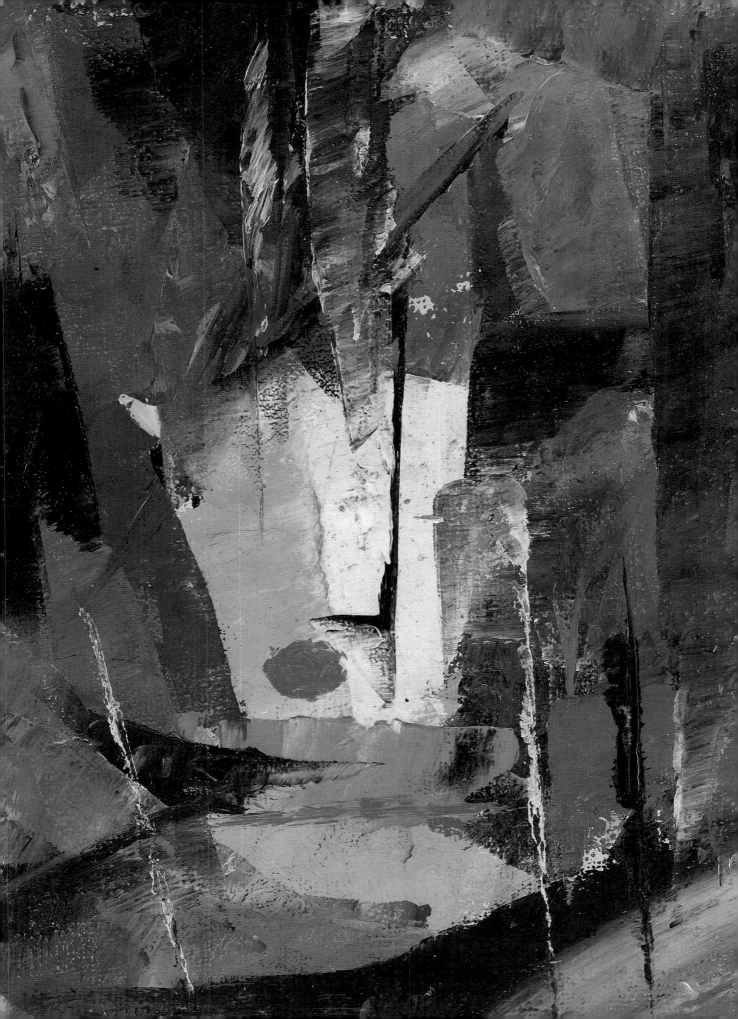

MATERIALS

It is better to have too many tools and materials than too few, and having items not usually recognised as painter's equipment can often lead the artist to experiment. He or she will probably – though by no means certainly – prefer one medium to another, but it is very rewarding to switch from one to another. Many of the tools connected with the various types of medium – oils, acrylic, watercolour, gouache, pastel, pen-and-ink and tempera – are interchangeable, and in fact, most mediums can be combined. In one picture, *The Refugee,* the artist Paul Klee used six distinct mediums and ten different 'layers'. It is often supposed that oil-based and water-based materials do not mix, but oils can be painted onto acrylic without problems, though not the other way about. Artists do not keep their various odds and ends in mental compartments, but swap things around as the mood takes them.

Always have plenty of brushes of all kinds and all sizes at hand

Adhesive tape There are various kinds, such as brown paper adhesive, Sellotape, brown packing tape, and masking tape, which is used to fix watercolour paper to a drawing board, and also to mask off part of a drawing or design so that paint can be applied without it infringing on the covered portion. It is very useful for painting crisp-edged areas of paint. For irregular areas, masking tape can be torn in strips and placed around the surface to be covered. The great asset of masking tape is that it can be drawn gently off the surface of the paper without damaging it in any way, which cannot be said of the other types of adhesive tape.

Air brush This is a torpedo-shaped device – once known as an airograph – which sprays a fine mist of directable, thin, coloured liquid onto a surface; it is much used in commercial art, and is marvellous for shaded effects. It is activated by compressed air, either from an aerosol container or a compressor run from the mains. An air brush can be used in combination with all water-based mediums and is particularly effective if used in association with stencils; its use can give a professional-looking finish with the minimum of trouble. However, if the liquid is too thick or is very quick-drying, there are blockage problems, leading to a good deal of annoyance on the part of the user.

Blotting paper For use mainly with watercolour and marginally with other water-based paints, but no use with oils. If a watercolour painting has got too 'strong', a sheet of blotting paper pressed onto it will cool it down, taking off superfluous paint until, if required, the artist has just the skeleton of the picture. Blotting paper can also be used to take out entire sections of a watercolour.

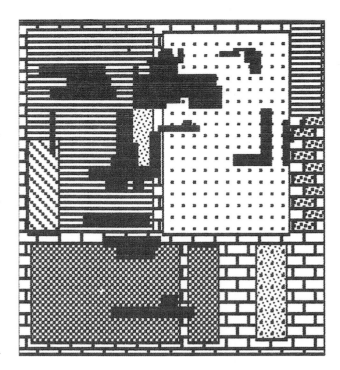

For a picture such as this a wide variety of brushes is called for. The larger black areas could be put in with a soft flat brush, with masking tape stretched around the shapes so that a crisp edge is achieved. The dark lines can be put in with a liner brush, or a very small flat brush; the dots with the point of a brush. The textured areas can be done with a sponge, dry flecks of paint applied with a shaving brush held vertically, or with a very tiny brush (perhaps 0000). Spattered paint using an old toothbrush is another option, if the surrounding areas are covered over with masking tape

Interesting effects may be obtained by making blotting-paper shapes such as circles and rectangles, placing them on the damp paper, and pressing down. Where a watercolour has been done in a series of washes, part of the top wash can be taken out in this manner. When used with gouache or acrylic, the use of blotting paper before the paint is quite dry can produce fascinating textures.

Brushes Brushes can be divided into two groups: stiff bristles, and hair; all can be used with any medium, and there is an immense variety. Some people prefer a lot of brushes, some a few, and many have their favourites which they have broken in and would not dispose of for the world. Both hard and soft brushes come in natural bristle, hair and nylon, and there is much to be said for nylon which lasts longer than natural products, especially with acrylic and oils.

A basic brush kit would include a small, a medium and a large round bristle; a small, medium and large flat bristle; a small, medium and large round soft brush (the best is sable, which retains its 'point' better than squirrel hair and the less expensive varieties); a small, medium and large flat soft brush; and two or three very fine brushes. The smallest of these is 0000 – a 'fan' brush, where the hairs radiate out in the form of a fan, and which is useful for blending colours and spreading them out; then comes a 'liner', a

small soft brush with very long hairs, invaluable for drawing lines, as its name suggests. Your kit should also include an ordinary household paint brush for applying a primer to a canvas or board, and perhaps varnish to large pictures; an old shaving brush for giving textures; and an old toothbrush can also come in useful.

Brushes can have long handles or short ones. When painting at an easel it is customary to stand away from it and hold the brush at full length. For working on the flat a long handle is not essential and can even be a nuisance, so have no hesitation in cutting it down.

With the best will in the world, brushes will clog when using oil-paints, but not immediately, and by holding 'loaded' oil-painting brushes in a jar of water the clogging action is suspended. A stiff brush will not hurt by touching the bottom of the jar, but a soft brush will, so do not let it. A simple way is to put a piece of card on the top of the jar with holes punched in it, and the handle of each brush can then be pushed up through the hole to the required length so that the bristles are kept off the bottom.

Even with the kindest treatment, do not expect soft brushes to last indefinitely when used with oils. One bird painter in oils would get through as many as ten soft brushes in the course of a picture, though admittedly he did not use stiff brushes at all but only the smallest of hair brushes, and each feather of the bird he was painting was

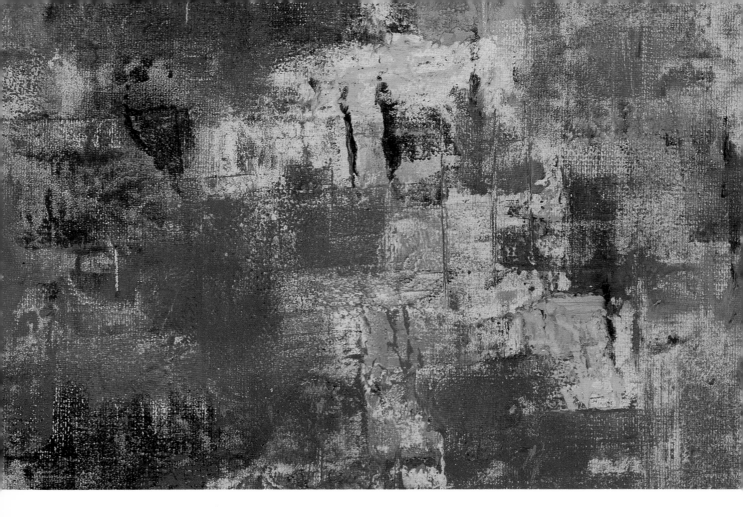

put on individually. It could take him two months to complete one picture. So although soft brushes will not die immediately, it is not wise to use a favourite brush for painting in oils.

After a painting session, wipe all brushes with a tissue or a piece of rag to get rid of the surplus oil paint, then wash thoroughly in turpentine or white spirit. At periodic intervals – perhaps once a month – wash the brushes with soap and hot water, paying particular attention to where the bristles are fixed to the handle with a metal ferrule.

Acrylic paints dry very rapidly and brushes should be kept continuously in water when not actually being used, placed horizontally so as not to damage the bristles. When using watercolour, gouache, or tempera, it does not matter much if the paint does harden on the brushes, for it will soon disperse when the brush is once again placed in water. Oddly enough, green water-colour paint tends to be more difficult to wash out of the brush than other colours.

To test a soft-pointed brush, wet it, shake off surplus water, and roll it in the palm of the hand to form a point. If the point is thin and weak reject it; and if there is too much 'belly' the brush will probably hold too much water and be sploshy in use. A new brush should never have hairs coming out.

Charcoal Used for putting in rough designs and for finished work. It can be taken out immediately with the finger tip, and it blends with most types of paint without leaving a mark. It is slightly messy and a charcoal pencil can be used instead, though this can be tiresome as the artist will spend a good deal of time sharpening it.

Cleaning materials A supply of clean rags is essential, divided into two piles: those to use for water-based products, and those for oil-based products. Linen is best, because straggling bits of thread do not come off on brushes and other equipment – old handkerchiefs and sheets are ideal. Kitchen roll is very useful for swabbing off palettes and mixing bowls, and if oil-paints have become impossibly congealed, Brillo pads can be used, quicker and more effective than the palette knife. When painting in oils make certain that there are ample supplies of turpentine or white spirit at hand, both for cleaning brushes, wiping off canvases, and for use as a medium.

Left:
An artist may never have too many materials of one kind or another. This picture, Summer Landscape was painted with oils using a soft brush. Tissue paper was laid on top while the oil paint was still damp. This took up surface paint. The tissue paper was then moved to another part of the oil-painting paper (which had little tooth) and the paint was pressed down on the fresh surface

Right:
In this study, blotting paper has been used to create the sharp white lines and the straight edges to the washes

Compasses Essential for the painter involved in geometric abstraction, and of course not only do they describe circles but also arcs. By taking out the pencil from the arm and putting in a soft pointed brush, circles can be painted in directly, though it needs some practice not to bear too heavily down when making the circles. Professional compasses come in a wide variety of sizes but these use a pencil lead rather than

Below left:
A selection of pointed sable brushes

Below right:
A selection of oil-painting brushes, although of course these can be used for watercolour, acrylic or any other type of pigment

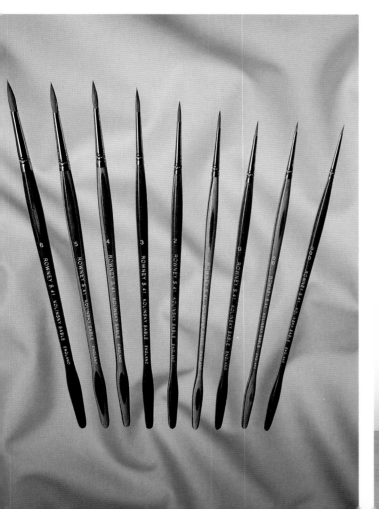

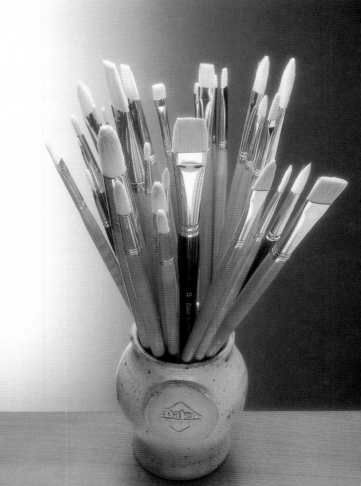

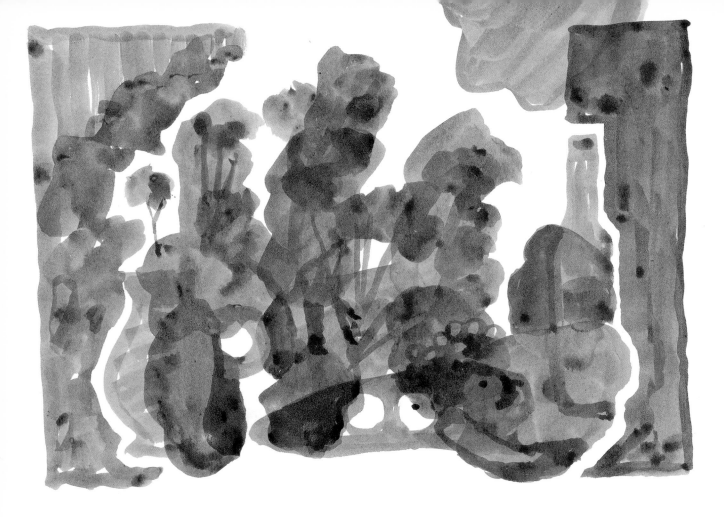

A still life in a landscape painting carried out using size 6 pointed sable brush. The medium is diluted Indian ink. Notice how 'negative' shapes produce images, as in the fruit

the pencil itself, and so cannot take a brush.

Containers Always use plenty of them. It does not matter what they are, and jam jars are as good as anything. When using watercolour you should have at least three jars of water, plus a bowl in which you can soak a sponge or cleaning rags. One jar should be reserved for clean water to use for washes. When using oils, do not skimp on turpentine or white spirit, whether it is as a medium or as a cleaning agent for brushes – cake tins are ideal for keeping oil mediums in. It is also very handy to have something to hold water which can be sprayed on to paper, such as a Windolene container, a diffuser, or a small garden spray.

Conté crayons Conté (pronounced contay) is a French manufacturer, and Conté crayons are not to be confused with the schoolroom product.

They come in oblong sticks and are often used as they come, without sharpening the ends. They are made in many colours, but the most used is black, a wonderful medium for fast sketching – much harder than pastel, but lustrous and easy to use – giving a thick rich black and on textured paper creating marvellous mottled effects. As with pastels, they can be used on the side for shading and covering large areas. They mix well with other mediums, but are inclined to 'ride' on a pastel base. Unlike charcoal, Conté crayons adhere to the paper and cannot be brushed off with the side of the hand.

Cotton buds A very useful adjunct, ideal for removing oil paint where it has drifted onto a surface where it is not wanted, for taking off surplus moisture from watercolours, and for blending all kinds of colours on the surface, especially when using pastel.

Craft knife or **Scalpel** Apart from their prosaic use sharpening pencils, craft knives and scalpels are very handy for scoring surfaces to provide texture, and when buying scalpels always get some spare blades, as there are many sizes.

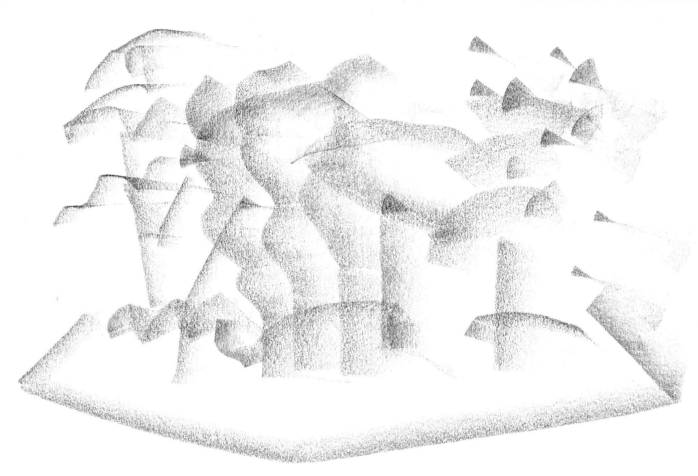

Above:
A landscape using Conté crayon

Below:
A cricketing scene, using a realistic outline figure with formalised clouds and cricket pitch. The horizontal white line represents the batting strip between the stumps, here shown as three squat verticals

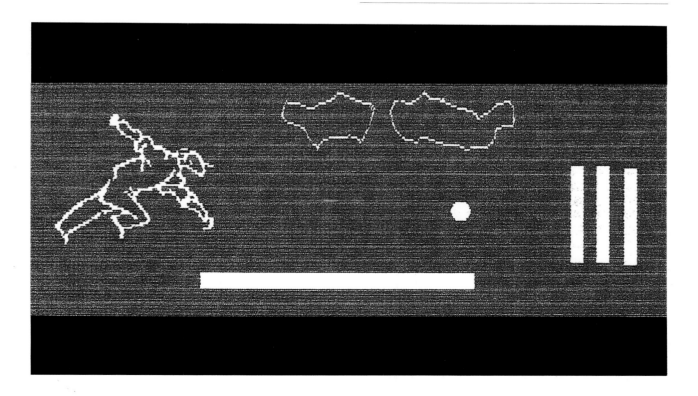

Replacement blades for craft knives are more explicitly labelled – these knives are also very useful when painting 'hard-edge' abstracts. Take a steel rule, and draw the blade along it, gently. This cannot be done on some surfaces, such as paper, for you will merely cut the paper in two, and if done on canvas, great care must be taken. The best surfaces are card, cardboard, canvas board, hardboard and wood, because the cut in the surface will provide a gully, and when you come to put in the paint it will go to the gully and no further, producing an absolutely immaculate edge. Craft knives can also be used to 'shave' pastel powder onto a surface, though this does not necessarily have to be a pastel picture. Pastel powder (even if water-based) can produce a fascinating effect on a painting in oils, giving a texture impossible to obtain by more orthodox means.

Dividers Not essential, but useful to compare shapes and distances when working out lay-out;

they also come in handy when 'scratching in' a circle on top of paint. A scratched-in circle is easier to paint in than a drawn circle, as the ridge made by the dividers forms a natural barrier to the paint, preventing it from 'leaking' outside the circle.

Drawing board When painting on the flat there is no adequate substitute for a professionally made drawing board, the structure of which ensures that there is no warping or sagging, often the case where a piece of plywood or board is used. A drawing board can also have an endless stream of drawing-pins bodged into it without signs of damage. For those who want a more resilient surface, a pad of newspaper can be set between the paper, card, or whatever, and the drawing board. Large drawing boards on a swivel stand as used by draughtsmen are excellent, though they do take up a good deal of room. When using watercolour the paper should be taped on, so that when it is treated with water it

Left:
Composition with Pinks, *in which a half-inch flat sable brush has been used throughout*

Right:
Queue, *showing how Conté crayon works very well in association with soft pastel*

Below:
Scalpels, craft knives, and indeed all pointed objects are very useful to score or otherwise break up a picture surface and to add texture, as in this oil painting *Tenements*

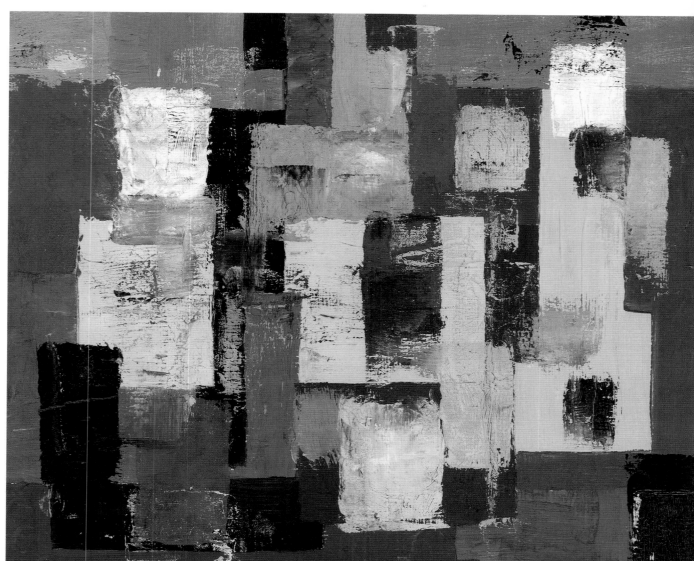

" Oh, Cyril—you've changed it ! "

stretches. An alternative to tape is the spring clip, and only slightly less useful is the familiar Bulldog clip, which has sufficient pressure to keep the paper taut.

Drawing pins For pinning paper to a drawing board, where adhesive tape is not wanted or needed. Heavy quality watercolour paper does not need soaking and stretching, and of course neither does card or any other rigid surface.

Easel This can be an option. Vital to a portrait painter and to traditional artists, but many painters of abstract pictures prefer to work on the flat or on a slight incline. If the picture is large, an easel becomes more important simply because it is impossible to bend over a canvas or painting surface six foot high.

There are many types of easel on the market, some with a tripod base (known as a radial easel), others which are heavy and are more or less fixtures, table-top easels, and simple folding easels with a multitude of adjusting screws. A 'donkey' is an easel combined with a seat.

Erasers The traditional eraser is the putty rubber which is very soft and gets dirty and messy very quickly so that is spreads grime around; however, because it is so soft it will not harm any surface. Plastic erasers are very efficient. The old-fashioned erasers found in children's boxed drawing sets are not universally to be recommended.

French curves These are transparent plastic devices obtained from shops which sell drawing-office equipment, and are basically stencils, each containing a variety of swirling curves.

Mahl stick This is decidedly a non-essential extra. It is a wooden telescopic rod, usually in three sections, with a globular tip and its purpose is to provide a hand-rest while the artist is doing detailed work on an easel picture when he is standing away from it. It helps to stop any hand tremor.

Masking fluid This is a milky substance which can be spread over any part of a surface to prevent it being covered by paint which is being applied to an adjacent part. It is spirit-based and is peeled off, but must be allowed to dry out thoroughly before removal, otherwise it is easy to take particles of paper away with it. Best used on hard or shiny surfaces.

Palettes Palettes were once made of wood, but now they come in all kinds of material – plastic, tin, aluminium, china and paper (throwaway palettes). The traditional ones for an artist painting in oils have a hole in them for his thumb. There are sometimes depressions in which to put paint, though the old wooden ones were completely flat and counterbalanced with a metal plate so they were comfortable to hold. For sitting-down artists, a large plate is just as good, and maybe better, for the dished sides prevent the paint spilling out. For standard palettes, small metal containers with clips are available which fit onto the side of the palette to take turpentine or other mediums.

Use the type of palette which suits you. If you are working on a large scale, forget the depressions in a custom-made palette and use jars, jar-tops or cake-tins, or the range of mixing dishes divided into segments. A 'stay-wet' palette is

Left:
An advertisement for a chair from 1928. There is no question that in another context this would be regarded as a valid abstract picture

And below:
More so if the image was turned on its side and incorporated with the original

available for those who paint in acrylics, and consists of a large plastic tray with raised sides, its base covered with a sheet of blotting-paper and a special paper which permits the water oozing from the blotting paper to seep through, thus keeping the acrylic colours moist. At the side of the tray is a division for keeping brushes moist. This palette is provided with a polythene lid so when it is not in use the colours are prevented from drying out – dried-out acrylic paint is useless and cannot be revived.

The 'stay-wet' palette is also very useful for gouache which will also dry out, but much more slowly; by adding water it can always be re-used.

Palette knife These come in various sizes and are used largely with oil paint, to clean it from a palette, or apply it (and acrylic) to canvas, either in dollops to be spread around with a brush later, or laying it down neatly. They can be used to complete an entire painting or can be employed selectively. The steel of the smaller knives is very thin and if damaged the blades lose their flexibility.

Pencils A variety of pencils from 6H (very hard) to 6B (very soft) should be kept (the standard office pencil is HB). Other useful drawing instruments are pastel pencils – thin leads of pastel which can be used with water-based paints; coloured pencils, some of which are soluble in water and can be used to give a watercolour effect; and the army of felt-tips. Laundry-markers and suchlike can be used to sketch out a broad preliminary design, but they should only be

employed when the medium to be laid on later is acrylic or oils, as they are penetrative and would show up under watercolour and lightweight paints. Felt-tips can be used freely on top of watercolour, gouache and tempera, and it is a good idea to consider them as paint-on-a-stick.

Pens There is much to be said for the old flexible steel-nibbed pen, which gives a variety of line lacking in the modern drawing-office instruments such as the Rapidograph. Users of the pen-with-a-nib also have access to an immense variety of coloured inks, which can be diluted and mixed with watercolour.

Rulers The best kind of ruler is transparent, so that the artist can see what he or she is doing; sharp notches to mark the divisions are not wanted. A two-foot rule is better than a one-foot, and folding rules are a nuisance as there is always a 'bubble' in the line where the rule is hinged. Some artists like to use the old-fashioned round ruler made of ebony, which used to be an

Dividers and other drawing instruments have many applications especially when working out distances between elements in a picture – although maybe only the artist is aware of their employment! How critical are the distances between the elements in this picture, Circuit*? It is a matter of opinion. To some it may seem a pointless exercise in bright primary colours. To others the disposition of the colours may make sense, giving the picture an air of repose*

nail small blocks of wood about 1/2in (12mm) high to act as supports. This is to execute straight lines with a brush – drawing a line freehand is not easy, and this ruler-on-stilts is invaluable in all mediums.

Sponge Sponges have been used in painting for very many years. We have all seen those Victorian oil paintings with a lake, a cottage, a blue sky, and a range of trees; the leaves of the

essential item on the desks of accountants.

A steel rule is used with a craft knife when putting in incised lines on the surface, and also when cutting mounts for watercolours (or acrylics, pastels, gouache and even oils); they are inclined to get slightly rusty so rub them over occasionally with an oily rag.

An essential accessory is a straight-edge of wood about 2ft (60cm) long, preferably with a bevelled edge on one side; at each end glue or

A selection of traditional wooden palettes. Some artists prefer throw-away paper palettes or dinner plates

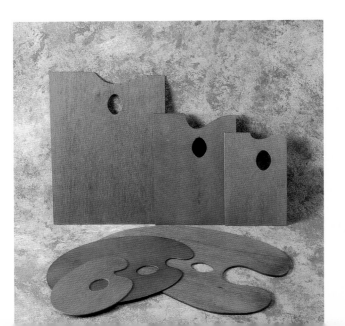

Above:
Flying Birds, *a watercolour using only French curves to make the shapes*

Below:
Amazonian Forest, *oil on oil-painting paper.*
This was created by using a palette knife on its side, placing thin lines of paint on a background of a dilute wash applied with a sponge

trees are tiny globules of green, brown and yellow, and from a distance look very effective. These were put in with a sponge. In abstract painting in oils a sponge can produce a unique mottled texture, either all over the surface or in selected passages. It is also useful when painting in watercolour, gouache, acrylic and tempera, not to mention pen and ink where a line can be 'blotched' and diluted ink can be redistributed on the paper.

The Victorians used natural sponge, but household and car sponges are nearly as good, if not quite. Artificial sponges usually come in rectangular chunks, and unless you want crisp straight edges it is a good idea to break a piece off so that you have a rough or rounded edge. If you want to use sponge on a small scale or for detail, take an even smaller piece and use it in a pair of tweezers or in a Bulldog clip.

A sponge is also invaluable for putting in a quick wash with watercolour where a background is wanted which need not be perfectly toned, and for adding blotches of colour to a surface.

Naturally a sponge used with oil colour is bound to get clogged up, but sponges are so cheap that when this happens the best thing to do is to throw it away.

Spring clips Used to keep paper in place on a drawing board.

Stencils Commercially produced stencils for draughtsmen can be very useful. There are many designs, and one of the best for the abstract

Above:
Mapping pens can give an extremely fine line, and as the nib is flexible there is more variety than with a Rapidograph pen

Right:
A picture carried out using very much diluted black Indian ink, a small sponge, and a 'chemical symbols' stencil, available at any stationers

painter is the stencil containing a variety of open circles. The advantage over using compasses is that the stencil shape can be laid down on top of the work in progress, and the artist can assess immediately whether it is the right size of circle or, indeed, whether he or she has need of a circle there at all. Various emblems and shapes are also available in stencil form; many of these have a scientific usage and include funnels and suchlike. Lettering stencils in various sizes can also be employed in abstract painting. The abstract artist uses a diverse range of shapes, so most commercial stencils will probably be of use.

It is very easy to make stencils. The material should be a 'crisp' card (so there is no fluffiness when it is cut) or polythene, or a material sold by

I am always struck by the way most people will insist upon trying to find at the back of abstract painting some abstruse theory, not merely of painting, but almost of the meaning of life itself. They discuss, explore and explain, and in doing so will use extraordinary analogies which only make the subject more confused and more remote than ever. But apart from the fact that discussions of this sort are usually stimulating and lead to a type of conversation which offers grand opportunities for imagination and delightful effusions concerning 'the Soul' (!), do they get us any nearer a solution of the problem? Don't they tend to make abstract painting so complicated that it becomes positively wrapped up in a sort of Hoodoo-ism – for the ordinary mortal, at any rate?

I believe that in all these discussions the material side of the question is not sufficiently emphasised – and here I shall show myself to be the real Philistine! I suspect that most artists (those who paint for their livelihood and not for their amusement) hope that they will sell their pictures, and the 'acid' test, as far as they are concerned, is whether someone likes their work enough to buy it.

L.F. Alliston 1934

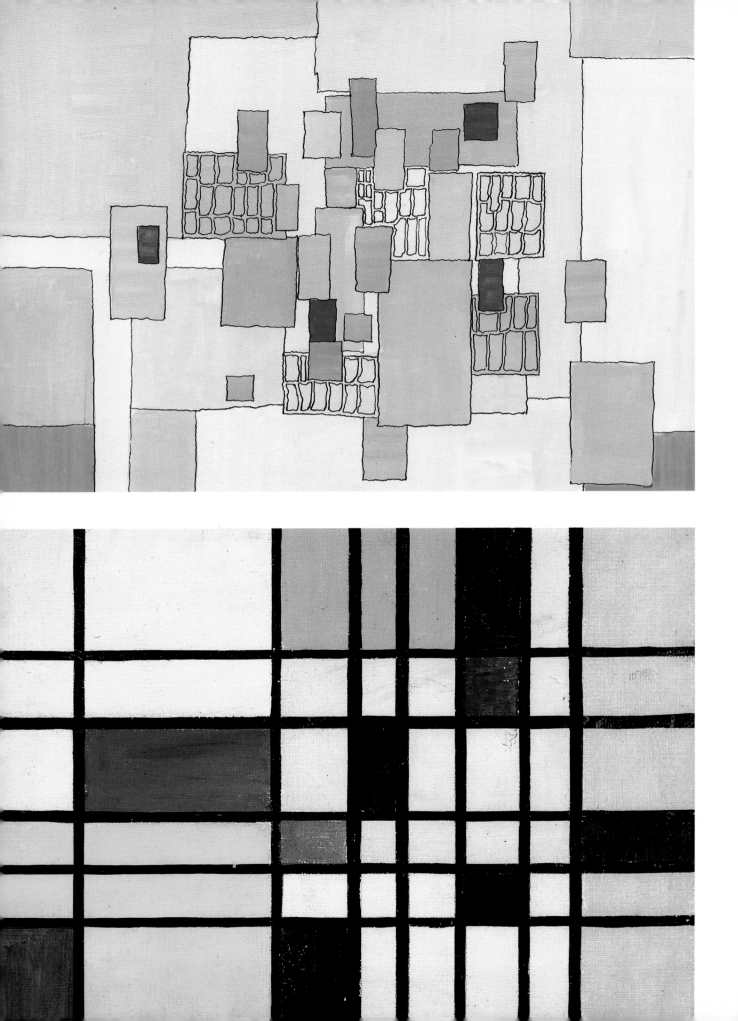

Left:
Roman Village, *watercolour on card, in which the use of pen and ink defines the various rectangles that make up the design*

Below left:
Rulers and set-squares are very useful in creating 'grid' abstracts, but there can always be a certain amount of variation in line thicknesses or other elements of the design to give a human dimension

Below:
A painting can be executed in one medium or more than one medium. There is no substitute for experimentation. In this painting, Amorphous Shapes, *coloured felt pens have been used in combination with watercolour, and it is interesting to see how the colour from the felt pens merges with the watercolour*

craft shops specifically to make stencils with. The shape should be cut with a craft knife or a scalpel. It is sometimes easier to take it out in sections, but if it can be taken out in one piece, this will make an 'inverse' stencil – in other words, you can place the shape down and paint round it.

The obvious advantage of stencils is that you can repeat the same shape over and over again, though one drawback is that a thin paint may 'drag' when you are taking the stencil off the painting surface. The answer is to use acrylic, because it dries very quickly – ten seconds, and the paint will be dry enough to withdraw the stencil without the paint spreading, and the acrylic can be used thick or thin. When applying paint to a stencil cut-out, dab it on; there are brushes made for this very purpose, but an old shaving-brush is perfect and cheaper – though unquestionably one of the best ways is to use an air-brush.

Stump or **Torchon** This is a short, stubby item shaped like a small cigar and is made of a blotting-paper-like substance. It is used with pastels and chalks to spread the powder about on the paper.

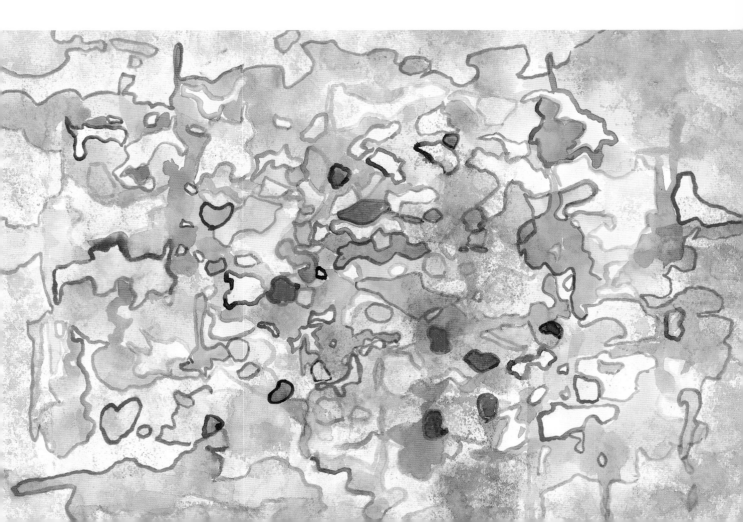

● ●

I consider that the artist has much better to do than merely to copy an object exactly as it appears to him.

Edouard Pignon 1947

● ●

Tissue paper Not household tissues which have a dimpled surface, but ordinary tissue paper as used for wrapping up parcels, much cheaper if bought in bulk rather than in single sheets. It can be used to take off superfluous oil paint so as to add subtlety to the picture – press it down flat onto the damp surface, and take it off when you think that sufficient paint has been absorbed. This method is known as 'tonking', and is named after Professor Henry Tonks, a teacher at the Slade School of Art, a very fine realist painter who specialised in atmospheric effects. The process is ideal for those who like to experiment – if the effect is not liked, the paint can be put back on again. The paint on the tissue paper will be a ghostly repeat of that bit of the design on the canvas or board, and by repositioning the tissue this 'echo' can be placed elsewhere on the picture, or even on another picture altogether as a 'start-off' motif.

T–Square Landscape artists, figure painters, and devotees of still life may never need to use a T-square, but it is an invaluable extra for abstract painters. It saves measuring up every time the artist wants to set in a horizontal line, and needs to be used in conjunction with a drawing board. An essential adjunct to the T-square is the set square, rested on top of the T-square to put in verticals or angles. A transparent set square is essential, and a large one is much better than the small ones found in schoolchildren's writing sets; it is also useful in drawing lines instead of a ruler, as it can be moved more easily over the picture surface. A protractor may come in useful, but is not essential unless the artist wants the angles and the direction of the lines to be absolutely 'right'.

Tweezers Not an obvious piece of equipment for an artist, but tweezers come in very useful for holding small pieces of sponge for sponge-painting or treatment, and for gripping tiny fragments of pastel when detail is needed.

Even stencil letters can be used to make abstract pictures

SHAPE TO LANDSCAPE PROJECT

The surface is first given a colour wash. The purpose of this is to take away the blankness of the white, and it can be of any colour and applied loosely, perhaps with a sponge if the medium used is water-based. The first shape is then put in, using pencil, pen-and-ink, pastel, coloured pencil, charcoal, or maybe the point of a soft brush. The shape can mean something or nothing

shape 2

shape 3

The second shape is then put in, overlapping the first. This is open-ended, because the limit of the picture is not yet decided, or what other shapes will be put in.
The third shape is put in.
The first two have been vertical. This one is horizontal to 'bind' the picture together

A border is put in. At this stage it seems a good idea to put in a border-within-a-border

*Another horizontal shape
is put in, rather more pointed, and
this suggests a kind of landscape
with standing stones, an inkling of
Stonehenge. A shape is inserted
suggesting a hedgerow. Not being
geometrical it forms a sharp
contrast to the rest of the picture*

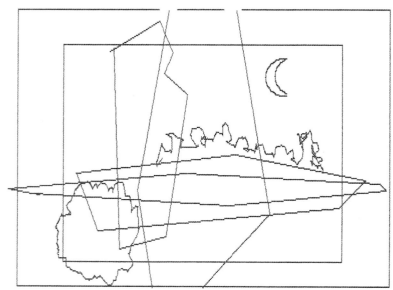

*Following on from this a
ragged blob is placed in the bottom
left of the picture. This can be
regarded as an accent, or it can be
interpreted as a bush-shape. To
give an accent to the top right of the
picture a crescent, maybe
representing a moon, is added.
Putting this in determines the
colouring – night-like not day-like.
There is also a possibility that
instead of using a range of diverse
colours it might be interesting just
to use a range of tones, perhaps in
browns and dark greens, with
maybe a touch of yellow for the
'moon'*

*In what may be the final
stage – though in painting an
abstract picture the artist can
continue to alter and embroider –
some texture has been introduced
to add variety to the surface, or
maybe suggest grass, and the blob
bottom left has been countered by
a blob bottom right. The surface
has also been enlivened by a
branch-like figure. If the picture is
seen as a kind of landscape this
can be interpreted as a branch of a
bush or tree through which the
scene is observed*

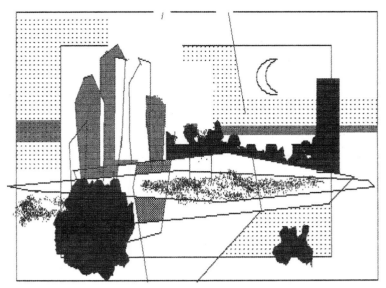

Continuing the theme and
making the 'upright stones' more
explicit, and changing the colours
and tones

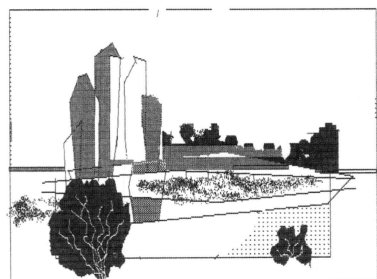

Accentuating the stones
by taking out much of the detail,
providing the 'bushes' in the 'front'
of the picture with a structure of
branches

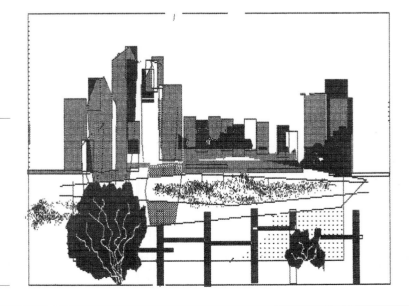

Perhaps the uprights
suggest skyscrapers or high-rise
flats? A form of grid is set in the
'foreground'. Notice how the
picture has lost its flat purely
decorative character, and how
perspective has crept in.
There is no reason why abstract
pictures should not have a
perspective element

SURFACES

Almost any surface can be used for painting on, and the technical name for such a surface is known as a 'ground'. All surfaces can be divided into two kinds: those suitable for oil-based paints, and those for water-based ones – these include paints such as acrylic which can be diluted with water. Some surfaces need to be prepared before the paint is applied, but many can be painted on right away. Amongst the materials available are:

Aluminium This provides a splendid surface for hard-edged abstracts. It does not need sizing or priming (unless there is an indication of surface damage which needs treating), and is best for acrylic and paints that do not 'slide'. It is sometimes an advantage to score aluminium with the blade of a knife to provide a tooth. Aluminium is worth considering for really big projects, perhaps for paintings intended for outdoors; it is not the only metal sheet that can be used, and it pays to look round the garage for possible material (though don't use old enamel signs – these can be worth hundreds of pounds!). For example, the metal 'For Sale' signs used by estate agents, which are usually left for the new buyer to get rid of, are splendid – the existing lettering can be covered with a primer, and you have a good surface to work on. And if carrying out a very large painting, consider using ordinary household paints, such as oil-based gloss, lacquer, and the wide range of water-based emulsions and commercial paints, as these are immeasurably cheaper than artists' colours (see Chapter 5, p56).

Card This can be mounting board or card of any thickness or colour. Mounting board is quite thick and is made in a multitude of colours, and provides a beautiful smooth surface ideal for hard-edged abstract painting. It will neither wrinkle nor buckle, and the colours of the board are 'fast' and can be used either as background or as colour elements in their own right. It can be bought in very large sheets, is not expensive, and is splendid for acrylic, gouache, and to a slightly lesser extent, watercolour. If used for oils it is desirable to size it, though painting oils onto card without sizing can result in a curious matt effect which is quite attractive – this is because the oils have penetrated through the card.

Cardboard Not a poor relation by any means, but a marvellous surface for oils, acrylics and gouache. Acrylics and gouache and all water-based paints can be applied directly, but when using oils it is necessary to size the cardboard (both sides) to prevent the oils sinking in and spreading. It is usual (though not essential) to give the cardboard an undercoat (priming) before use, one reason being that its brown colour is perhaps not the best background colour to work on. If paint is applied thickly it does not matter, but if a translucent quality is wanted the brown cardboard acts against it. There is a slight agreeable tooth to cardboard.

Canvas The classic surface for oil painting, robust, slightly flexible, and giving a good 'feel' to the artist, and almost everlasting. Paintings on canvas can be constantly altered, and easily obliterated by overpainting. Shop-bought canvases are usually primed (with an undercoat), and stretched, ready for use; they all have a marked tooth, which varies between rough and fine. Ready-made canvases are not cheap and if you want to work on a large scale they can turn out expensive, but against this is their versatility and the fact that they can be constantly re-used. They can also be used for acrylic.

Above:
There are certain subjects which lend themselves to large scale, perhaps screens or murals, as in this piece using repeat images of the 1920s flapper (left)

Canvas can also be bought from artists' colourmen in rolls, primed and unprimed, but you will have to stretch it yourself – the result will not be as professional as the shop product, but it can be done quite easily. Use an old picture frame, tack the edges of the canvas to the reverse side, and make the surface taut with wedges inserted between the frame and the underside of the canvas. There are various types of fabric used in the manufacture of artists' canvases: cotton duck, embroidery linen, artists' linen, unbleached calico, flax and hessian. Hessian is the coarsest.

Canvas board This is canvas stuck to board, as the name implies, and is every bit as good as canvas except that it is a rigid surface with no give in it. It is much cheaper, and can be bought in a

49

large variety of sizes with coarse, medium, or fine tooth; it, too, is eminently suitable for acrylic. If canvas is robust, canvas board is all but indestructible – it can be worked on time after time, and furthermore cannot be punctured or split by accident as canvas can.

Canvas paper This is bought in a block or pad, with a fairly small range of textures, but it also provides an excellent surface for both oils and acrylic. There is no need to remove the top piece of canvas paper to work on; leave it on the block.

Cartridge paper Obtainable in various thicknesses, much cheaper than watercolour paper and in many cases quite as acceptable, especially when using gouache, tempera, pen and ink, or acrylic, when the rather tame surface will be a help rather than a hindrance when painting geometric abstracts. However, cheap thin cartridge paper should be avoided.

Chipboard An alternative to wood, and useful for oils and acrylic, suitably sized and primed. Canvas or other material can be stuck to it. If the canvas is saturated with size, the size will not

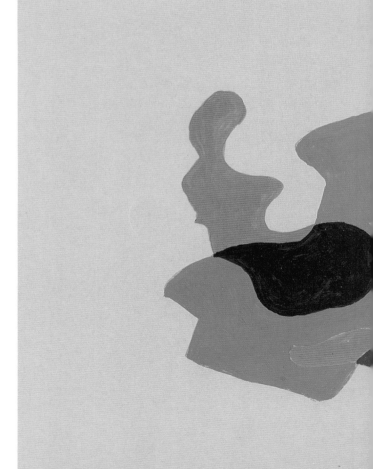

Left:
You make your own rules. You could have your shapes in three dimensions, as in this gouache on untreated paper, in which there is a decided influence of the French Surrealist painter Yves Tanguy. This picture has been heavily varnished without letting the first coats dry thoroughly; the result is a curious puckered effect on the surface

Right:
A collage and wood construction by Roy Ray. He has used hand-coloured tissue, cast paper (paper moulded by the artist), acrylic paste and paint, and the ground is carved and constructed wood.
The subject relates to Roy Ray's interest in archaeological objects and also landscape imagery

Below:
Boxers *is acrylic on coloured paper thick enough to resist bubbling*

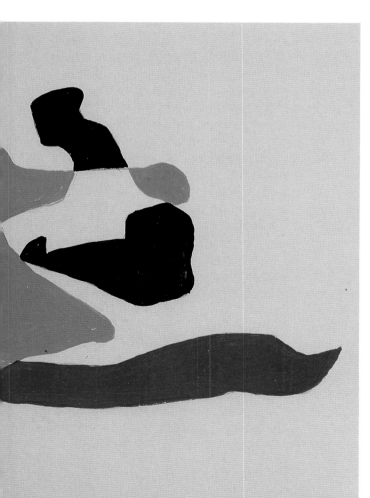

only give a suitable surface, but will act as a glue and stick the canvas to the board.

Fashion board This comes somewhere between card and watercolour paper and is delightful to use, sturdy, and with a slight porous quality that makes it ideal for watercolour treatment. It is more expensive than ordinary card.

Glass This takes paint well, and is useful if making an abstract in layers, with one glass painting on top of another so that they complement each other. The best-known exponent of painting on glass was the surrealist painter Duchamps.

Hardboard Remarkably versatile and much used by starving artists in attics who cannot afford canvases; another advantage is that it can be bought in huge sheets. It should be sized and primed, and the paint can be applied on either the rough or the smooth side, the latter being perhaps the most useful for abstract painters. The tooth on the one side is very coarse and can absorb a lot of paint, so it might be wise to consider domestic paint, with or without the addition of artists' pigments. Hardboard can be used for acrylic, and also for tempera and gouache when it should be primed with a non-oil primer, such as an acrylic primer.

Ingres paper This is primarily pastel paper, made in a great variety of colours and with a small, even tooth so that it takes up the pastel powder as the stick is being used. It is quite thin,

and although it can be used for gouache and watercolour, it is inclined to buckle up and bulge – though this can be stopped by wetting the sheet of paper and taping the edges down with masking tape or brown adhesive tape. As the paper dries it will stretch and give a drumhead rigidity.

Plywood Plywood is a first-class working surface especially suitable for oils and acrylics, though if there are knots in the surface it should be avoided. It is cheap, long-lasting, can be obtained in large sheets, and can easily be cut to the desired dimensions. When using oils, plywood needs to be sized because it does absorb a certain amount of the oil.

Polythene With all the other surfaces available, it might be thought that painting on polythene was a needless option, but one of the features of this synthetic is that it can be transparent. In the past, abstract painters have painted on celluloid, but with the propensity of celluloid to yellow and crack, polythene is decidedly preferable. Why paint on transparent substances? To make a painting in depth, in several layers; these various layers can be kept apart by plugs at the corners, or they can be arranged to slide across each other so that a different picture can be disclosed – after all, abstract painting is the art of adventure. Polythene takes acrylic and gouache paints very well, though the gouache has to be fairly thick otherwise this water-based paint forms into small globules.

Silk This is a minority option for those who want to see abstract art in action, in a pattern on a dress or perhaps a tie. It must be emphasised that abstract art is not necessarily something to put in a frame and stick on a wall – furthermore, silk and other fabric paints are now widely available

from art shops, so it would be a mistake to use acrylics, gouache or oils when the exact painting medium is available. Of course, painting on silk has been done for centuries, particularly in the East. Equally, abstract pictures can be made without using pigments of any kind – needlework and tapestry are admirable examples. In the 1930s rugs were made which were really abstract paintings made to walk over.

Slate Slate is an excellent surface for gouache and acrylic. It needs no preparation and the design can be drawn on in pencil, or incised with a craft knife or scalpel. It may not be everyone's choice, but slate tiles come in a convenient size, and the background colour can also be utilised.

Vinyl Not by any means one of the standard surfaces, but well worth experimenting with, as it provides a delightful, smooth surface. Perhaps acrylic is the best type of pigment to use.

Walls Murals may not be to everyone's taste, but in a sympathetic household, who knows? The best surface is emulsion, and unless the artist is intending to use dozens of tubes of artists' paint, commercial paint is obviously the better alternative. Absorbent surfaces can be nullified by size, and polyurethane varnish can be used on emulsion, either applied with a brush or by aerosol.

Watercolour paper This comes in a multitude of textures and thicknesses and is splendid for all kinds of medium, including oils (if the paper is sized). Two of the principal types are HP (hot-pressed) which is smooth, and NOT (not hot-pressed) which is less smooth and has a tooth. Some watercolour papers are tinted, and the variety now obtainable is incredible; it includes pads of black paper, very suitable and stimulating for abstract work. Somewhere between watercolour paper and card is a satin-smooth paper called Ivorex, which takes watercolour very well. So there is a type of paper to suit every need – and the best is handmade from rags. Watercolour paper is categorised by weight, with the lightest 72lb, and medium weight 140lb; heavyweight paper does not need stretching.

There is supposed to be a 'right side' to watercolour paper, but if there *is* much difference it is difficult if not impossible to spot. Some watercolour paper bears a watermark, which can be seen if the paper is held up to a strong light – if the

• •

Abstract art is the reduction of painting to its absolute fundamentals, the 'bones' of geometry upon which all is built. It is the placing of squares, oblongs, circles, lines, in such a subtle and delicate relationship that on their own they can evoke a satisfactory picture. Some think it is the very 'dry bones' and do not get any pleasant reaction from seeing such canvases, but others are thrilled by them. A certain kind of temperament is essential for this sort of pictorial expression, but at its best it can undoubtedly be very satisfying to the intellectual mind.

R.O. Dunlop RA 1950

• •

watermark is the right way up, you are viewing the 'right side'. The tooth of ordinary watercolour paper is perfect for pastel work.

Wood Wood panels were once the classic 'support' for works of art before the full-scale arrival of canvas. There is nothing against their use except expense, and wood also needs sizing and priming. Some woods are woolly, such as pine, and it can be annoying if bits obtrude above the surface. Alternatively, mahogany was often used by the great masters of the past and is a splendid surface to work on; in fact the close-grained woods are much better than those with a loose grain. And with the current enthusiasm for painting furniture, why not take one of your more nondescript pieces and reconsider it as a surface for an abstract painting, rather than as something to adorn with decorative twiddly bits? There is nothing novel in this. Furniture was painted with abstract designs by a prestigious arty-crafty group called Omega Workshop more than fifty years ago.

• •

In an attempt to give a more profound truth to reality, we aim at portraying the image of a recorded sensation rather than of a vision as merely seen. We seek to go beyond, and not outside of, the appearance of things.

Jean Bazaine 1947

• •

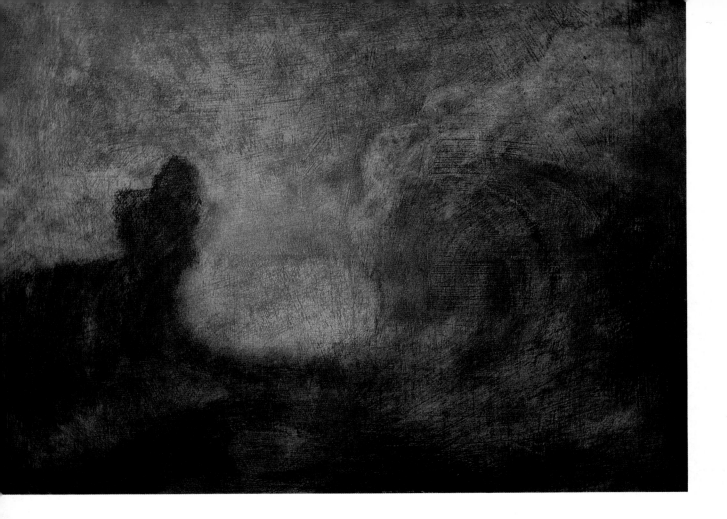

Above:
In his work, David Pearce uses as his ground marine plywood (less liable to buckle than ordinary plywood), on which he uses a mixture of plaster-of-Paris and white emulsion. This very satisfying picture is inspired by a seascape near his home in north Cornwall

Left:
For dreamy washes, as shown here in Coral Life, 90lb watercolour paper is ideal

Right:
This watercolour and gouache work, Sunset at Cowes, is painted on one of the 'classic' watercolour papers, David Cox, which is slightly brown and very rugged indeed. Before the 'yachting' emblems were painted in, the background was scrubbed with a nail brush to produce the fading effect

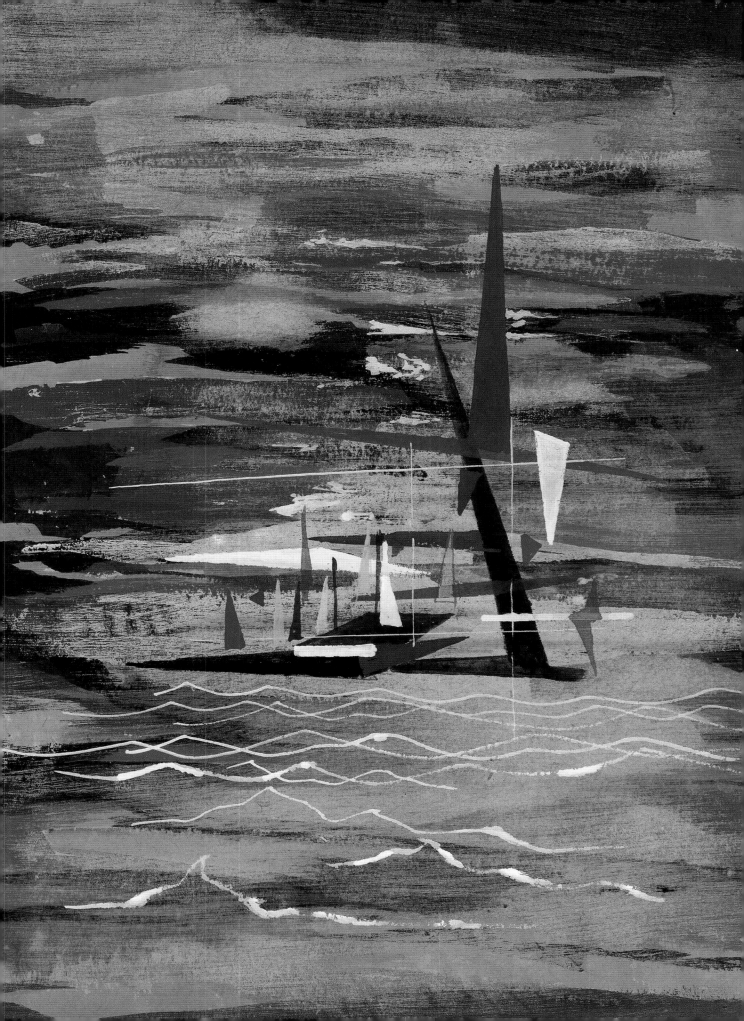

PAINTS

There are two basic types of paint, oil- and water-based; oil colours are put on a canvas with a brush or a palette knife either neat from the tube or mixed with a medium to make the paint run smoothly. There has always been argument as to which is more difficult, oil or watercolour painting, but really the answer to this is that neither is too hard if tackled sensibly.

OIL PAINTS

Until the last century artists made their own colours, and the results were often erratic. Today artists' oil colours usually come in tubes, and these are often marked with asterisks denoting the degree of permanence, although even 'fugitive' and what are known as 'fancy' colours will show little if any colour fading, even over a long period.

There are many kinds of medium to go with the oil paint, some simple, some more complicated, and some artists mix their own, though the manufacturers' own brands of medium are excellent; and oil paints can often be used direct from the tube. The simplest medium is turpentine or white spirit. Some writers advise pure turpentine for mixing and white spirit for cleaning, but no-one has ever complained about the adverse effects of white spirit. Turpentine imparts a matt finish, and because it is thin, is very good for detail.

Linseed oil is the traditional medium, and this can be mixed with turpentine. It is a fairly slow dryer, as is poppy oil; petrol is very useful, and can be bought as lighter fuel in handy, safe tins. Liquin is a relatively quick dryer, and varnish straight from the bottle can be used as a medium – this gives a rich effect when applying the paint. Whatever medium is used, a picture will not dry out while you are continuing to paint on it.

Varnishing

A picture can be varnished on completion with either a matt or glossy varnish. It is usual to recommend that the painter waits some time before varnishing – sometimes as long as six months – although a picture can be safely varnished when it is finger-dry; though remember paint put on thickly takes longer to dry. A softish, flat brush should be used, as a stiff-bristle brush may leave parallel strokes in the varnish surface; special varnishing brushes can be bought. The most convenient way to apply varnish is to use an aerosol, and modern polyurethane varnishes have a good deal to commend them. Two thin coats are preferable to one thick one. 'Retouching varnish' is a varnish made to liven up 'dead' passages on a picture.

ACRYLIC PAINTS

Acrylic paints are wonderful: used thickly they can be mistaken for oils, in a wash they are a slightly grainy watercolour. They come in tubes, though there is not the same range as oil colours. Their key feature, which cannot be emphasised too much, is that they dry rapidly – this is wonderful for those who like to get on with their pictures, for they can continually overpaint; no need to remove unwanted passages. But it does mean that the caps of the tubes must be replaced as soon as the paint is squeezed onto the palette, and, again, the brush bristles and hairs must be kept moist.

Acrylic can be used on virtually any surface – those who want to try it out for the first time and who are reluctant to use 'proper' paper, canvas or board, can use a newspaper. An acrylic primer is a thick white paint much like household undercoat, and can be put on an absorbent or semi-absorbent surface. It also dries quickly.

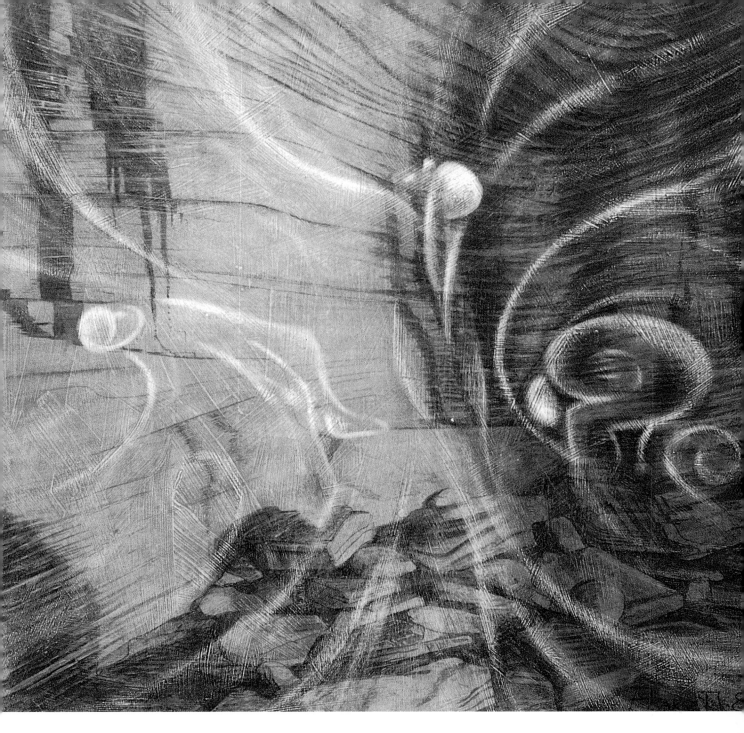

If acrylic dries too rapidly for your purposes, there is an acrylic retarder which slows up the drying rate; a texture paste can also be bought which builds up the paint level (the 'impasto') but this is inclined to lighten colours. Acrylics can be used with water or with a medium, which can be either matt or glossy. Acrylic varnish is a white, milky substance which can alarm a newcomer because it makes the surface of the newly varnished picture opaque – as soon as it dries, however, it becomes absolutely transparent. The varnishes used for oil paints are quite serviceable on acrylic pictures.

Constantine Bay, *acrylic on marine plywood, by David Pearce*

Acrylic paint can be used with all other water-based mediums, though because of its power and covering ability it can obliterate more sensitive mediums. It can be drawn on with pencil, pen, pastels and felt pens, and an underpainting of acrylic provides an admirable base for a fully fledged oil painting.

Watercolours in tubes and pans

WATERCOLOUR PAINTS

Watercolours are pigments mixed with a gum which serves as a binder; traditionally this was gum arabic, but other binders are used as well. It comes in tubes and pans, and you can use whichever is the most convenient; it is highly concentrated, and a little goes a long way. Normally only water is used as a medium, but gum arabic can be added and so can megilp, which gives brilliance and acts as a retarder. In boxed or tinned sets of watercolours there is usually a Chinese white; however, this has very little covering capacity, and if you are using white in your watercolour painting, go for white gouache.

The phrase 'if you are using white' may puzzle. It derives from past practice, for in early English watercolours white was not used – the paper showing through the tints was used for highlights. This was known as the English style; the French style was watercolour painting in which white paint was used. Many professional watercolourists today continue to paint in the English style.

Gouache

Gouache, or opaque watercolour, has a variety of names including 'designer's colour' and 'poster paint', and comes in tubes, pots, and in powder form; it is supplied to schools cheaply and in large quantities. Unless you are aiming for grainy effects, powder paint is no good to use. White gouache is sometimes sold as 'process white' and is used for obliterating mistakes in pen-and-ink and black-and-white work; it can be used as ordinary white gouache.

After a time, gouache and ordinary watercolours will go solid in the tube. If this happens, cut the metal tube, put the watercolour in a pan and the gouache in a container with a screw-on top, and add water. Watercolours and gouache can be used together, and combined with inks; tempera is also compatible.

Tempera

The commercial packaging of tempera is fairly recent, but it is a charming medium which has many of the qualities of gouache. It is somewhat absorbent and is usually put on in delicate layers, in small strokes which dry speedily, so that the

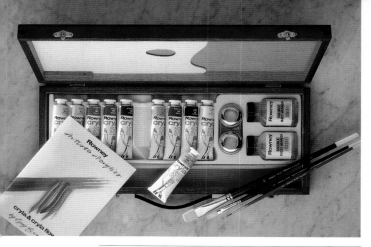

Above:
A range of acrylic products

Right
A traditional oil-painting kit

Below:
Falling, *a watercolour in three layers – the basic wash, a mixed mid-tint, and colours straight from the pan or tube with just enough water to make the paint run smoothly*

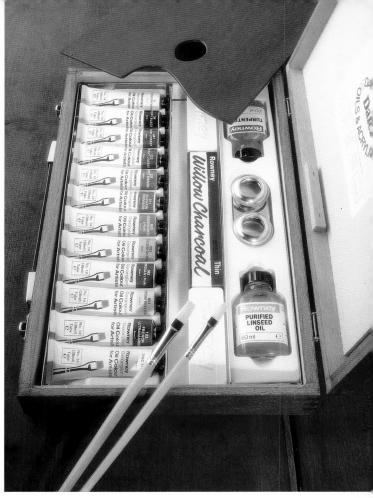

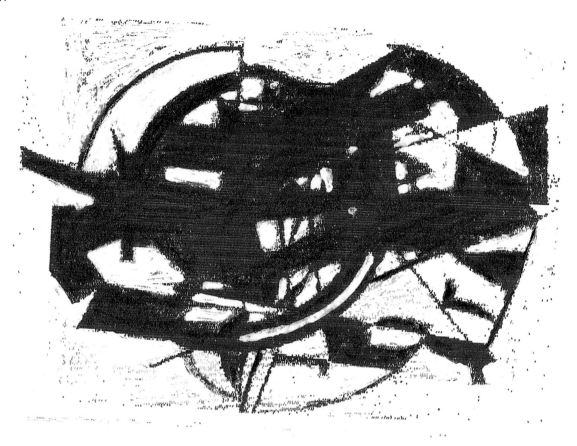

paint blends. It can be made by mixing powder pigment with the yolk of an egg, but it is much more convenient to buy it in tubes.

Varnishing

It is not usual to varnish watercolours, but it can be done and watercolour varnish is available. Gouache and tempera can be varnished with oil varnishes, but this must be applied softly or the surface may be drawn off. Do not use oil varnishes where the paint is thin or where the paper shows through, for it will stain.

• •

There were some who became pre-occupied with aesthetic qualities and the joys of handling their medium – joys that were purely abstract, as the 'thing seen' did not occupy their minds even as a thing to be departed from.
Fascinated with manipulating the tools of their trade, they became inspired 'doodlers'.
The high priest of this doodling school was Klee.

David Ghilchik 1952

• •

PASTEL

There are two basic types of pastel: water-based and oil-based; the oil-based is little used, though can be employed with oil colours. Pastels are powdered colours mixed with water and chalk and fashioned into sticks; a binder is put in to stop the pastel crumbling, and the less binder used the softer the pastel. Soft pastels are more effective than hard pastels. Pastels are sold singly and in boxed sets, with a compartment for each pastel which is wrapped in cotton-wool or tissue to protect it from damage. When bought, pastels have a paper sleeve, but this will soon be tattered and broken, as will the stick itself; the fragments of pastel can still, however, be used, by holding them in tweezers.

There are hundreds of tints available in pastel, with more than a dozen greys – green-grey, blue-grey, etc – and they can be used in many ways. The colour can be put on in individual strokes, changing from tint to tint; pastel sticks can be used on their side; pastel powder can be shaved onto a suitable surface using a scalpel or craft knife, or can be mixed with water and used as a paste (this is where the name 'pastel' comes from). Colours can be blended on the paper using

Left:
The use of texture can make a picture much more effective, even when it is hardly discernible.
This is a computer-produced image reinforced with Conté crayon, and overlaid with typewriter correcting fluid

Right:
Pastel is best used when the shapes are ragged. If sharp edges are needed pastel can be supplemented with pastel pencils or coloured pencils

a finger tip, a cotton bud, a stump (a compressed pencil of blotting-paper or a similar substance) or a brush (either bristle or hair), wet or dry.

Pastels are usually used with a slightly grainy paper such as Ingres paper, and pastel paper is widely available in a multitude of colours; a pastel-paper block will probably contain a dozen different tints. However, any kind of paper can be used including watercolour paper, brown wrapping paper, cartridge paper, and even sandpaper; although very smooth papers can cause smudginess. Pastels can be fixed with an aerosol fixative, though purists do not care for this as they say that it destroys the 'bloom'. When the fixative is first applied, the picture goes very dark which can be alarming, but this soon goes and no colour change takes place. After a pastel painting has been fixed it can be varnished, though only use an aerosol. It is not customary to varnish pastels, but that is no reason not to try it.

• •

Dazzled by the wealthy stakes of cheap commercialism and fascinated by high-falutin theories which are no more than covers to excuse bad painting and bad ideas, it will take all (students') courage and resolution to lift this noble profession from the mire into which it is sinking to the heights of which it was justly proud in the past and will be justly proud in the future.

Claude Muncaster RWS RBA ROI 1952

• •

Pastels can of course be used in abstract painting, although for hard-edge painting and geometric abstraction they are not really suitable as there is bound to be a certain amount of fluffiness at the edges; however, a pastel pencil (a pencil with a narrow length of pastel, similar in appearance to coloured pencils) can effectively pick out detail. Pastel pencils, as well as coloured pencils, are very good to work with when doing watercolours or gouache paintings.

PEN AND INK
Pen and ink can be used by themselves or with watercolour, gouache or tempera, but not with oils. They can be used with pastels, but there is a tendency for the nib to get blocked with pastel dust. There is a great variety of nibs, from those used in mapping pens upwards; some nibs are fitted with a reservoir. Fountain pens are excellent, as are the Rapidograph cartridge pens which can produce an extremely fine line, impossible to get by any other means. Inks come in all colours – some are waterproof, some are not. They can be diluted, mixed, flicked on, splashed on, and mixed with watercolour.

HOUSEHOLD PAINT
Thus the range of standard artists' paints and pigments, all of which can be used separately or in combination. However, none of them needs to be used at all, as we can turn our attention to the vast range of household and domestic paints. These are available anywhere and are immeasurably cheaper than artists' colours – not

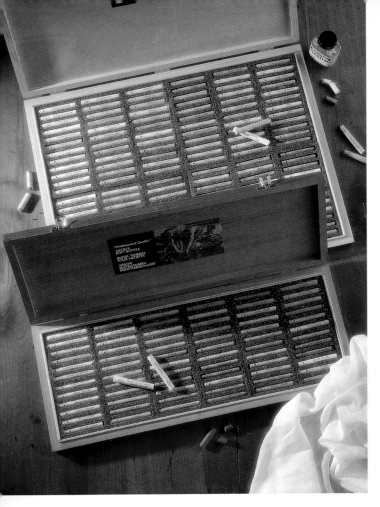

Left:
Pastels come in a marvellous range of tints,
but sometimes it is easier to use
a small selection

Right:
Pastels are not often used in abstract painting,
but there is no good reason why they should not be.
Used sideways they give a good sharp edge

Below:
A landscape by Rebecca Roberts, exploiting a full
colour range

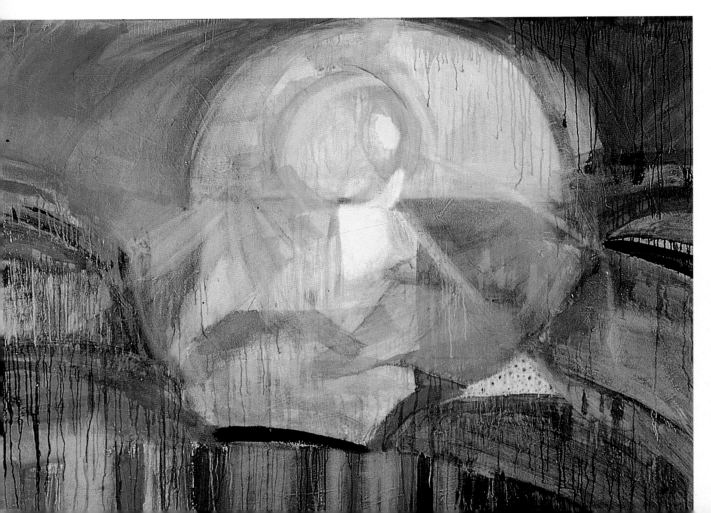

● ●

If you're no good, go modern

Teacher at Birmingham College of Art 1951

● ●

important for small or medium-scale works, but a factor to be considered where a large picture is contemplated. Naturally they do not bear asterisks to denote their durability, but the equivalent of household paints was used for centuries for murals in churches, and those were paints without any quality control.

Nor, of course, is there the range of colours available that is found in artists' pigments – but that does not matter, for artists' pigments can be added to household paints and any required colour can be made. As always, all oil-based paints mix with each other, and so do water-based.

Water-based emulsions are perhaps the most versatile and useful of the domestic paints, and are available in matt, silk, and glossy finishes. They dry fairly rapidly, but not inconveniently so, and depending on the surface, can be used with a primer or directly. If pastel colours are wanted, it will be found that a small amount of artists' gouache mixed into a decorator's white will be stronger than imagined. It is a good idea, especially when experimenting, to take small quantities of household white from the tin, put these in small screw-topped containers, and then add the artists' paint. If the mix is too thick for use with soft brushes, water can be added.

Oil-based domestic paint can also be tinted with artists' colours, using white spirit if it is too thick. Eggshell finish is perhaps the most useful. If a highly reflective surface is wanted gloss paint can be used; and if the picture turns out too glossy, it can be toned down with a matt varnish. After the picture is completed, it is worthwhile considering the potential of the range of coloured varnishes now available to DIY enthusiasts. Polyurethane varnish can be employed on both emulsion and oil-based paint.

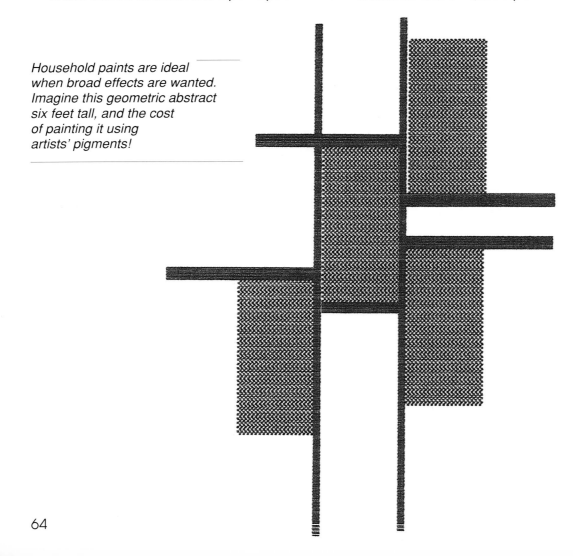

Household paints are ideal when broad effects are wanted. Imagine this geometric abstract six feet tall, and the cost of painting it using artists' pigments!

CIRCLES PROJECT

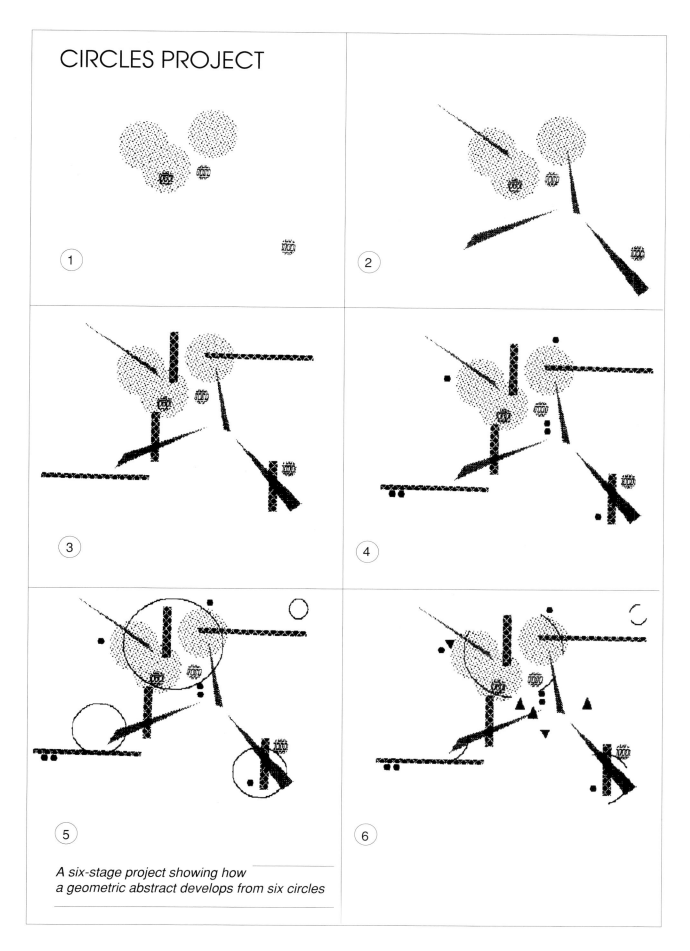

*A six-stage project showing how
a geometric abstract develops from six circles*

TECHNIQUES

Paint can be spread on, dabbed on, even sprayed on, and there is no one best way. It depends on what the artist prefers, and which specific technique is suitable for the particular picture. There are certain basic techniques, such as laying on a watercolour wash – though for a 'casual' wash there is no need to do any preparation at all, not even to fix the paper to the drawing board, except maybe for a couple of drawing-pins in the top corners which will stop the paper sliding around; the wash can be put on the dry paper with a large soft brush or a sponge. Otherwise, water can be sprayed on – use an empty Windolene container or a small garden spray – with a little colour dabbed on with a brush so that the wash spreads in a haphazard and unpredictable manner.

This is a good idea when you have no preconceived notions about the picture, what it is going to be, what colours you are going to use, even what the ultimate medium is to be. But a svelte smooth wash *does* need a modicum of preparation.

If you are using watercolour paper first wet it, either with a sponge or put it under the tap, letting the surplus water drain off. Place the paper on the drawing-board, with or without a pad of newspaper beneath it, and tape down the sides, using masking tape or brown adhesive paper tape. Brown tape was introduced in the 1920s; before that, paste was used. Brown paper tape is some-

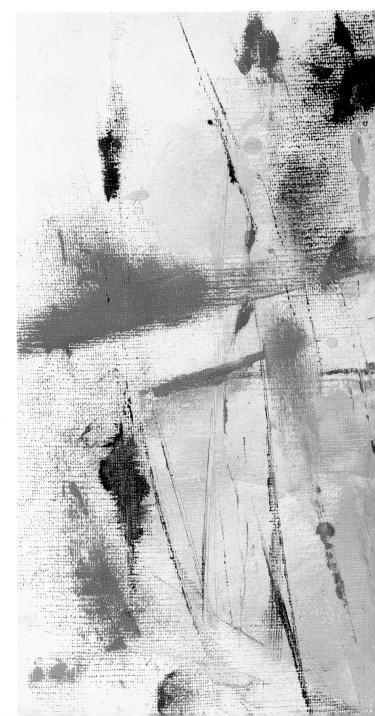

When is a picture completed?
This oil painting on oil-painting paper could be
the preliminary design for something more
elaborate: just a framework, establishing the areas
of colour. Or it could be considered finished

what cheaper than masking tape, but masking tape can often be re-used. Try to place the paper symmetrically on the board, because if you are doing geometric abstracts you will probably be using a T-square and a set square and you will want the paper to be exactly square on. So test that the edges of the paper are absolutely horizontal and vertical with the T-square and set square. You don't have to spend time making certain the tape is exactly the right length — overlap at the corners if you wish.

When the paper dries out it will have stretched, giving a taut surface to work on. A wash can be applied if the paper is wet or dry.

WASHES

To lay in a good wash, mix a reasonable quantity of paint — a little goes a long way — into clean water, either in a pot or in one of the depressions in the watercolour tin. Using a large soft brush, either round or flat, load it with the thin mixture, and, tilting the board towards you so that the colour runs down, take the brush smoothly along the top of the paper. As the colour collects at the

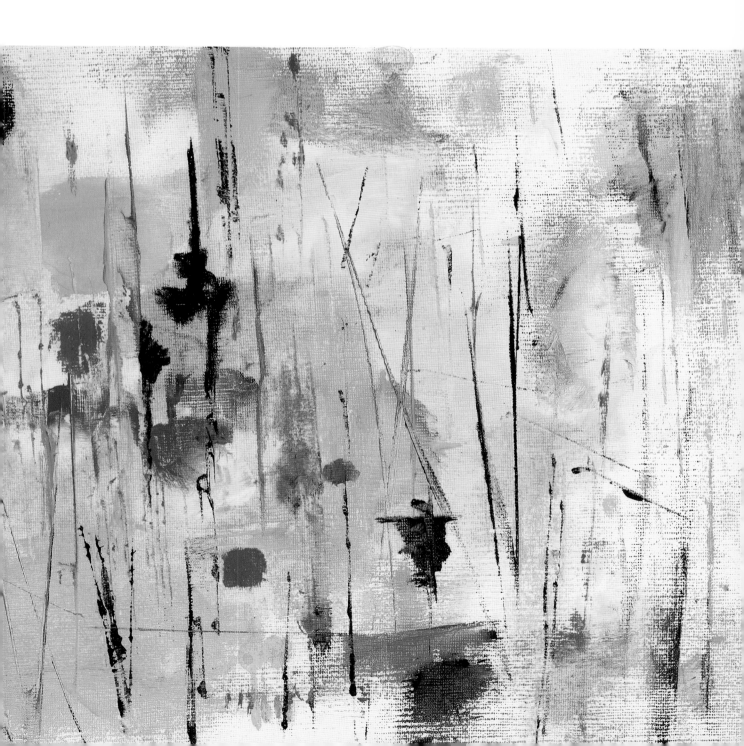

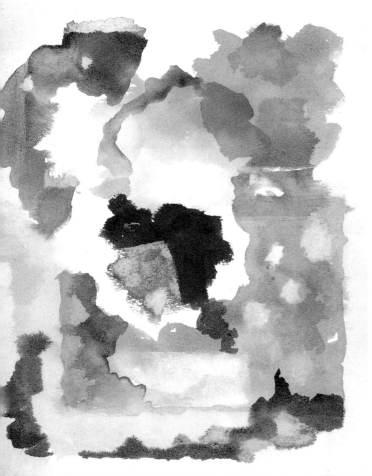

Above:
A study in 'washing out', showing how
subtle effects can be achieved by taking out colour
using a brush, a sponge, or blotting paper.
There are at least five tones of colour
between white and black

Left:
An empty sheet of paper or a blank
canvas can be awesome. Get something down,
even if it is only a wash. By adding a little colour to
the wash and letting it spread, there may be
something that sparks the picture off. It could be an
interesting shape, it could be a vague image

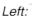
Right:
This is a study in the use of washes of varying
intensity and how they relate to small areas of solid
colour, but also shows how 'spattering' can create
an effect. This type of painting is extremely popular
and has a marked resemblance to aerial
photography

bottom of the stroke, lay a further overlapping stroke, and so on down the paper. If the colour is moving too fast down the paper, alter the angle of the board. The paint will collect at the bottom. Dry the brush and mop it off with that, or with tissues, blotting paper or a sponge. For a graduated wash add a little more water to the wash as you carry on down the paper – at the bottom you may have nothing but pure water.

You can do it the other way round, starting with pure water and adding more paint, but this graduation is more difficult to control and it is far simpler merely to turn the paper upside down when the wash is finished if you want the dark tones at the bottom instead of at the top. Paint can be added at any stage when carrying out the process, even if it is of a different colour. A succession of washes can be applied, and the most amazing and subtle colour effects can be produced in this way.

'Washing out' means creating a highlight in the paper, taking away a section of wash and letting the white of the paper show through. The dryer the paper, the more crisp will be the edges of the area taken out. Use a small brush to mop off the area of wash, finishing off with tissue or blotting paper; a fuzzy-edged area can be produced by using a sponge. A complex white shape can be created by brushing in the required area with masking fluid prior to applying the wash, which will ride over it. When all is thoroughly dry the film of masking fluid can be peeled off, but carefully, otherwise the surface of the paper will go with it.

Oil paints and acrylics can also be employed in washes, though in acrylics, however well watered-down, there will always be some graininess due to the tiny fragments of paint which will not dilute to nothing. The medium to use for oil washes is turpentine or white spirit, and the smallest dab of oil paint will be enough when mixed with the turpentine.

When a wash has been established it can be painted on using watercolour, gouache or acrylic, without much danger of it being taken off by subsequent paint. Some watercolours can be completed just by using washes, first background, then picking out the shapes, then refining any detail. Watercolours can also be applied in a half-and-half mixture, and in full strength straight from the pan or tube with just sufficient water to make them manageable. The design can be put onto the paper with charcoal, a pencil, a pen, or the tip

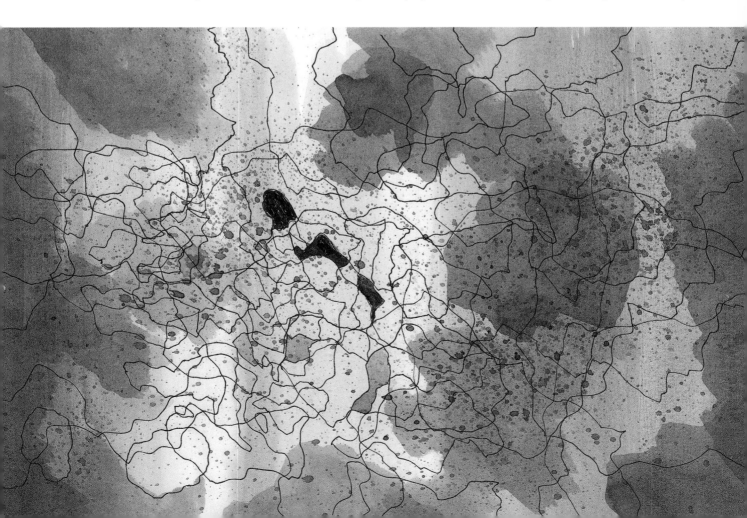

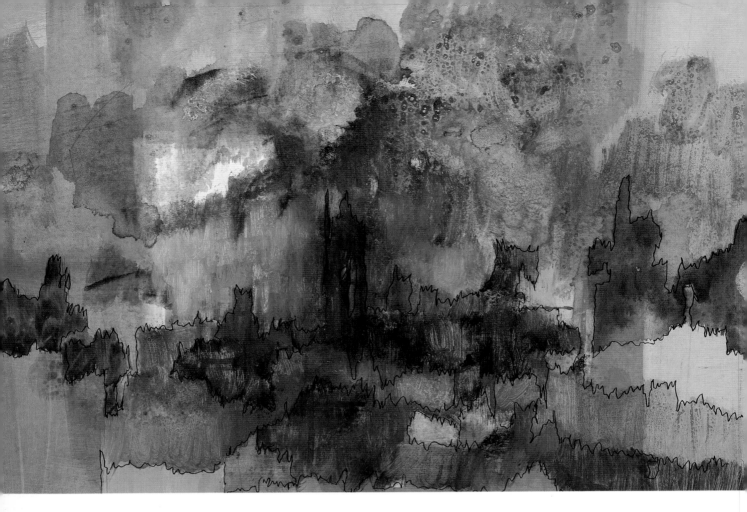

of a brush – indeed, any instrument that makes a mark. It can be an outline, or a complete drawing with shading and indications of tone, and afterwards the colour can be splashed on, spattered on (flicking the brush with the finger or the end of a ruler) or applied carefully, keeping to the rigid outlines of the preliminary drawing.

Painting a shape

When applying full colour to a shape there are several ways to go about it. One is to start by outlining the inside of the shape with a fairly small brush, then fill in the shape from the outline inwards using short strokes of paint, slightly overlapping. Another is to place the paint in a blob in the middle of the shape and work towards the edges, using the paint in the blob as a sort of reservoir. When using watercolour this has to be done fairly rapidly while the paint is still loose. The dry brush method can also be used – paint with hardly any water at all on the brush.

Brushes

Brushes can be of any size and any shape: besides the orthodox round and flat brushes, there are flat-tipped brushes with the hair cut at

Above:
Boston Stump in Storm, *watercolour on gouache, shows how washes can be used to give texture. The washes have been laid on loosely, and then partly taken off using blotting paper. Areas have then been gone over with a bristle brush, so that the wash blends with the underlying gouache. Features are then picked out with pen and ink*

Above right:
Water Reflections *by David Pearce*

Right:
Mermaid *by Rebecca Roberts, with oil paint used as a wash*

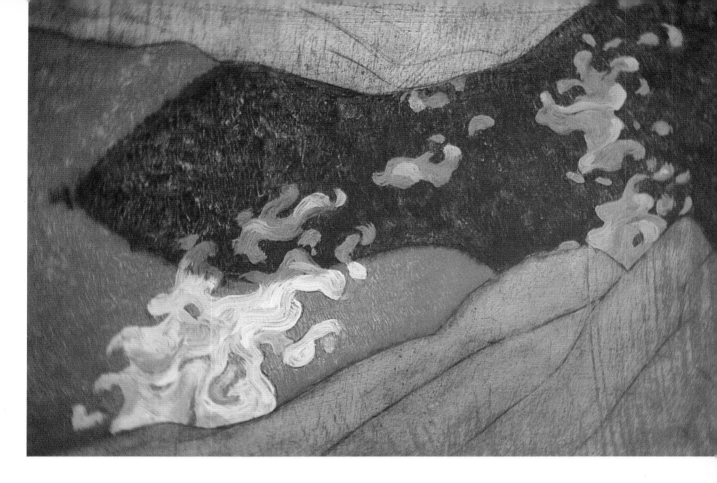

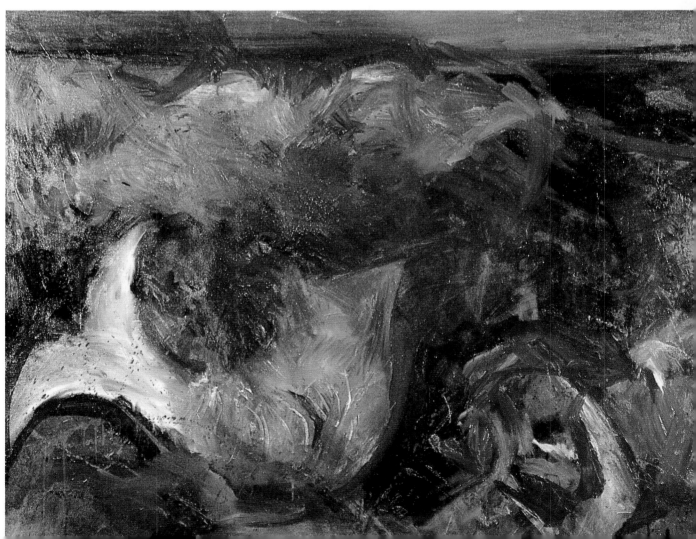

a slant, 'liners' with long hairs, and fan brushes. Bristle brushes as used with oil paints can also be brought into service.

Paper

Good watercolour paper is one of the most sturdy of materials and an artist can work on it over and over again. Be as busy as you like, piling colour on colour and texture on texture – you are the one who decides when to stop, and great watercolour painters of the past have worked on their pictures until the surface of the paper has become pitted and even torn.

PAINTING IN OILS

More people will have been introduced at an early age to watercolours or gouache – in the form of schoolroom powder paint – than oil paints, so painting in oils may be more of a novelty, though certainly not a challenge. First of all, a suitable surface must be selected, whether it is canvas, canvas board, or canvas paper, or even one of the DIY surfaces such as cardboard or card, though remember that however admirable these are, they do lack a tooth. As with watercolours, a wash can be laid down. It will soon be hidden by paint, but it will take away the glaring white of the surface, and if you are sketching in a preliminary design or meticulously laying out the design for a smooth geometric abstract, it is easier to do it on an off-white or tinted surface. You can put the wash in with a sponge, perhaps using different tints to spark something off if you are not certain what you are going to do other than paint some kind of picture.

The first choice to make is whether to work on the flat or on an easel. If you are concerned with sharp shapes, crisp lines, spot-on colouring, without any fuzziness or soft edges, it is probably better to work on the flat; a coarse tooth or grain will take more paint than a fine tooth or no tooth at all. You can mix the paint where and how you like – on a palette, in a dish or saucer, or on the canvas or surface itself. If you are working only in pure colours, it is not a bad idea to mix the colours in separate cake-tins, or in the mixing dishes with partitions; and if you are using a restricted range of pure colours – such as red, white, blue, yellow, and black – you could have a different brush for each colour which will save having to wash out the brush each time. In fact this is no problem at all, as a wiggle of the brush in a bowl or jar of white spirit and a brisk dry with a cloth will clean it

Right:
A simple grid pattern can lend itself to elaboration, and an interesting effect can be achieved by inverting the tones, making the grid white or light-coloured

Below right:
Colouring in and patterning segments is one of the oldest methods of creating abstract pictures. The patterns can be as simple or as complex as you like

sufficiently, but it will save a little time.

Have plenty of brushes available in all sizes. It is annoying to come to a little bit that calls for a small sable brush, maybe to fill in a corner of a square, and find that you have to leave off painting and hunt around for one.

You can mix all the paints you want, or you can mix the colours as you need them – to start off with you may not know what paints you are going to need. Many artists lay out their paints in a set order on their palette from light to dark. Some oil paints are thicker than others, and need more of a stir-up when they are going to be used. The kind of medium you use does not matter; oil paint is manageable with all of them, though the use of pure varnish will make application a trifle heavy. If you like an instant gloss, a ready-made medium is ideal, but turpentine can hardly be beaten when it comes to fine detail.

Techniques in oils

Coming to the actual business of painting, there are basically two traditional oil-painting techniques: direct painting; and painting in layers, where an undercoat is used, then maybe a second or a third, all contributing to the final result. These underpaintings have an effect on the layers coming after, and may partly show through, or may influence the appearance of the colours on top. For example, if you put a black down, let it

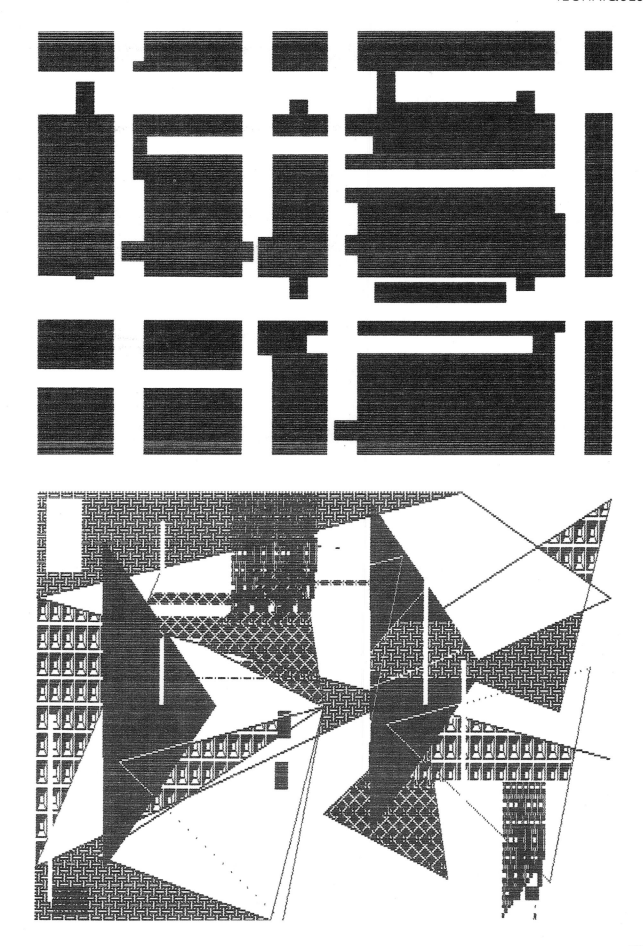

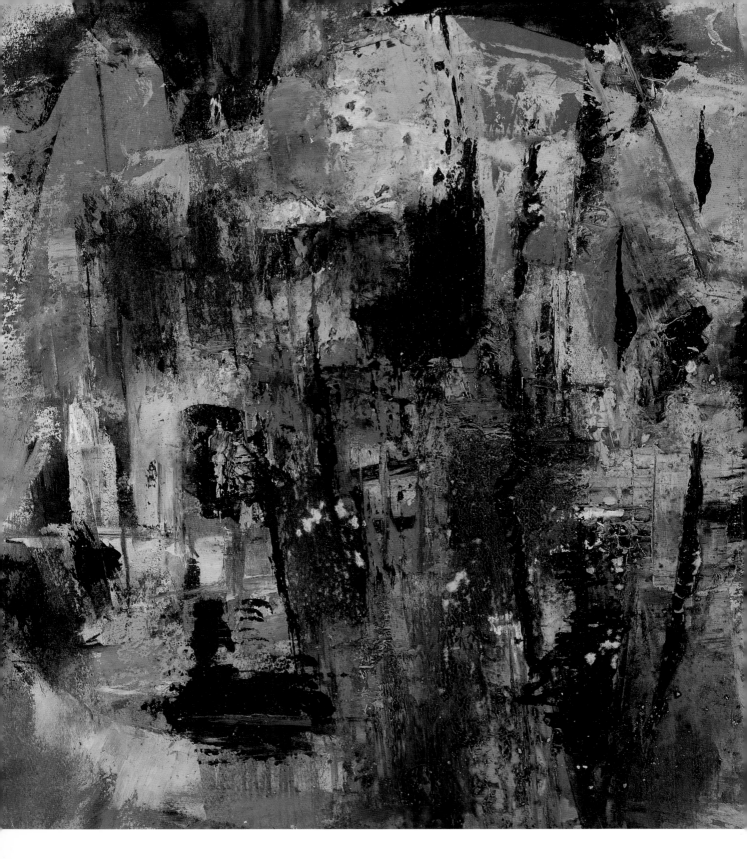

*Overpainting can be carried out many
times. In this picture paint has been applied in
several layers by brush, palette knife and sponge.
Sponging produces an odd mottled texture difficult
to obtain in any other way*

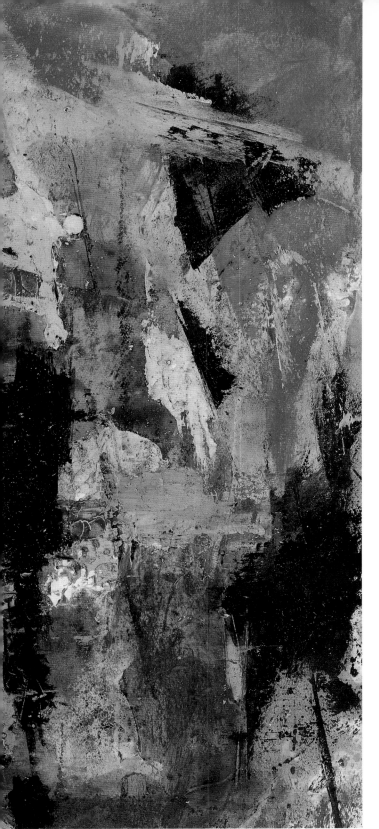

• •

I remember suddenly coming on a cubist Picasso at the end of a small upstairs room at Paul Rosenberg's gallery. It must have been a 1915 painting – it was what seemed to me then completely abstract. And in the centre there was an absolutely miraculous green – very deep, very potent and absolutely real. In fact, none of the actual events in one's life have been more real than that, and it still remains a standard by which I judge any reality in my own work.

Ben Nicholson 1944

• •

dry, and then put a light coating of white over it, you will certainly not get a pure white.

Painting in layers can be time-consuming, for although there are substances that can be added to oil paints to speed up the drying process, even using these you will be held back. The under-coats must be reasonably dry before paint is applied on top of them, for otherwise there is no point in putting them down, unless you want the undercoats to blend in with each other. Of course, it is up to the individual; the artist can switch from one technique to another as the painting takes shape. In art, there are no hard and fast rules.

A blank canvas can be a formidable thing, so get something down, no matter what it is – perhaps a grid drawn in pencil or charcoal. Al-though charcoal leaves a woolly line, it is very versatile – it can be brushed off with the side of the hand and it disappears completely in oil paint, whereas if the paint is used fairly thinly, a pencil line may still show through. Perhaps draw a squiggle. And if you are uncertain about what you are going to do in oils, dabble about in acrylics for a while and use what you have done as a basis to work on. With oils and canvases you can always obliterate what you have done by scrap-ing a palette knife or an old kitchen knife across the surface, and wiping the canvas off with a cleaning rag or a sponge. And you can always cover up what has been done, even if it is a preliminary skirmish with acrylics, with another layer of paint; you cannot take acrylic off, how-ever, once it is down, but only overpaint.

Notice how the circle in the centre acts as a connecting link between the four geometric groups

Painting a shape

You can put in a few shapes. They can have ragged edges and can be left so, or cleaned up. See what they suggest: do they call for other, similar shapes in different colours? Could they be put in space, so that some shapes are behind and some in front? This can be done by adding in 'receding' colours such as blue and 'advancing' colours such as red.

Shapes can also be put in using stencils, especially with the draughtsman's aid, French curves. These can be pencilled in using the stencil, or the stencil can be placed over the picture surface and painted over (when this is done remove the surplus paint from the top of the stencil – if it is oily it gets on the hands; if it is acrylic it sets and has to be scraped off).

Do these shapes suggest everyday objects, and if so do you want to pursue this? Do you want to paint everyday objects as they are, but in a more simplified form, for example making a solid silhouette of them? Or do you just want to suggest actual forms? This can be done by emphasising 'realistic' features such as the handle of a jug, which may be evoked (by accident) by an arc produced using French curves. Shapes – ragged-edged or immaculate – can be put on with a

• •

Think of [abstract paintings] not as 'pictures' but as 'objects' – objects possessing a certain kind of life, objects absorbing and giving back life . . .They become parts of the space you live in. The 'identity between canvas and idea' has become absolute: painting crosses the conventional boundary between 'art' and 'life'.

John Summerson 1948

• •

flat bristle brush or a flat soft brush. Move from brush to brush as the progress of the picture demands.

This process can be carried on until the glimmer of a finished picture comes through, and this you can pursue, altering and amending until every feature and every colour has been changed out of all recognition. You can carry on refining for days if need be. Artists of the past have sold pictures, having worked on them for years – and even then, some of them have taken these same pictures back off their owners to put in what they considered the final touches.

Perhaps you have already put in your design; it may be something with intersecting segments, each of which you intend to colour with flat stark tones to make an all-over pattern. You may want to make the limits of your painted shapes razor-sharp, and the way to do this depends on the material being painted on. If it is card or canvas board you can score the boundary lines with the point of a scalpel, so that when the colour is applied it will go to this gully and then stop. If the surface is likely to puncture with this kind of treatment, put the main body of colour in, but keep away from the edges. Then take a small soft brush lightly loaded with medium, and gently draw the sitting paint to the borders. With a straight-edge (preferably on home-made stilts, as mentioned on p38, Chapter 3), draw along the line with a brush. Then even out the paint with the soft brush, finishing off with a larger brush so that a perfectly integrated paint layer is obtained. If there is some overlap with the next colour this can be put right by drawing a brush just inside the boundaries so that the adjacent colours edge up to each other.

If the flat colour segments need to be enlivened with texture (such as stripes, dots, lattice-work), wait until the paint is dry, for otherwise you are bound to get some dragging. This is where gouache and acrylic sometimes prove more suitable, for you can paint on textures almost immediately (and if they don't work they can be obliterated with another coat of paint, especially those in acrylic).

A simple design,
showing how the circle at the bottom right acts
as a pivot to the other circles

Techniques with acrylic, etc

The basic techniques used with oils can be employed in acrylics, gouache, and tempera; these are all less messy, and free from the pervading smell of oils and turpentine. However, there are one or two minor restrictions: if you are laying on successive washes keep to watercolours, acrylics, tempera, and oils (where the process is known as glazing), and not gouache, for with gouache the surface will soften and there will be a certain amount of sliding paint. This feature can, however, be utilised for 'misty' pictures.

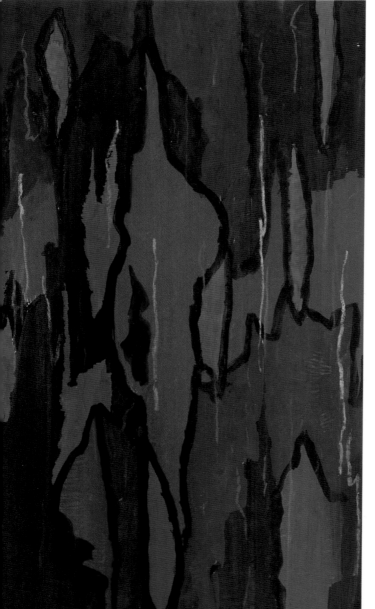

Above left:
Dead Thought *by David Pearce.*
The artist usually establishes his basic design in charcoal. Notice the 'cracking' effect on the yellow circle, created by the use of plaster

Left:
Pastels can be used with other mediums.
In Flames in a Fire, *delicate strokes in yellow pastel are placed against a rich background painted in acrylic, the shapes emphasised by outlining in black*

• •

When I went to the exhibition of abstract paintings by the so-called École de Paris I felt physically sick. I would have called them nonsense paintings or not paintings at all, just paint dabbed on a canvas regardless of common sense, and it was like being in a paint factory when they were trying out the colours. You have to say something for Nazi Germany which banned paintings like this.

L.S. Addison, sporting artist, 1950

• •

Varnish

When the picture is finished, you may, or may not, choose to varnish. A varnished picture can always be worked over if necessary, though if gloss varnish is used, the shiny surface may not be to everyone's taste. However, varnishes which turn out to be too aggressive can always be taken off. Oil-based varnishes can be used perfectly well on acrylics, and gouache too if a soft brush is used carefully. Acrylic varnish is a milky substance which does not affect the picture surface and can be worked on almost immediately.

Collage by Roy Ray
(enlarged from 60x60mm), using
hand-cast paper, acrylic paste and acrylic paint on
canvas. The artist begins with a textural white
surface and then applies his colour washes and·
paint. Roy Ray uses a subtle restrained palette, so
that any strong colour he uses – the red, in this
case – is given added emphasis

PASTELS

Pastels are not used so often in abstract painting; there is no particular reason for this, except that it is difficult to get real crispness with pastels, though the use of pastel pencils does help. These are very good for fluffy, non-geometric abstract paintings, and of course can be used in association with other mediums, including oils and pen and ink, to diversify the textures. Note that when pastels are being used, a certain amount of pastel dust will build up on the picture surface, and this should be gently tapped off. Pastels can be used held like a pencil, used flat, while fragments can be put between the prongs of tweezers. When a picture is finished it should be sprayed with an aerosol fixative to hold the pastel in place, but it is a good idea to employ the fixative throughout the course of the painting, for not only does it stop the colours smudging and sliding but it provides a good tooth for further pastelling.

With canvases, the whole area should be covered; on other surfaces, you may care to provide an inner border – this can be a feature in itself, made into a frieze and suitably decorated, or it can be plain.

*A rapidly executed piece
in gouache on card, using a brush very
lightly loaded with paint so that the bare card
shows through. Despite its simplicity this picture
works very well. Why? No-one can really say.
It just does*

SUMMARY

The most important thing in painting a picture is to be able to apply paint in a way which is pleasurable, and which looks good. In other words, get the professional touch. There are many different ways to apply paint, of course, and this is just a brief summary:

Bristle brush, using all sizes

Bristle brush, using only large and medium brushes

Bristle brush, using only the smallest sizes

Soft brush, using all sizes

Soft brush, using only medium and large flat brushes

Soft brush, using only the smallest sizes (0000-0)

Bristle brush and soft brush combined

Palette knife

Palette knife and bristle brush

Palette knife and soft brush

Finger tip

Sponge

Tube of paint using nozzle as applicator

Varieties of texture are obtained by:

Overpainting on existing surface when paint is dry

Overpainting on existing surface when paint is wet

Taking off paint with sponge, tissue-paper, or blotting-paper

Adding extra paint with sponge, tissue-paper, or blotting-paper

Dabbing at surface with bristle brush

Gouging surface with a pointed instrument

Laying on extra paint with palette knife

Taking off some paint with palette knife

Spraying on paint with a diffuser

Overdrawing with pencil, pen, felt pen, crayon or pastel

Spattering with a pen and ink

Spattering with old toothbrush loaded with thin paint

Smoothing out paint with finger tip

Applying paint with the aid of a stencil

Applying paint straight from the tube with the nozzle as the applicator

Taking off watercolour with a soft eraser

Taking off watercolour by soaking painting under running water

Taking off oil paint by immersing board etc, in a bath of turpentine

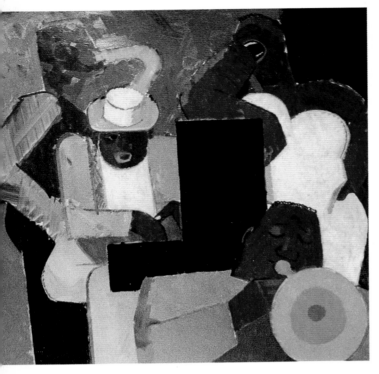

Above:
A wonderful oil painting using straightforward brushwork, by Sam Dodwell RI; one of his series depicting jazz subjects. The circle in the bottom left-hand corner representing the bell of a trumpet echoes marvellously the yellow saxophone top left, and the black rectangle-plus of the piano gives great stability to what might be described as a neo-Cubist painting

• •

Abstract painting is abstract. It confronts you.
There was a reviewer a while back who wrote that
my pictures didn't have any beginning or any end.
He didn't mean it as a compliment, but it was.
It was a fine compliment.

On himself, in Francis V.O'Connor,
Jackson Pollock.

• •

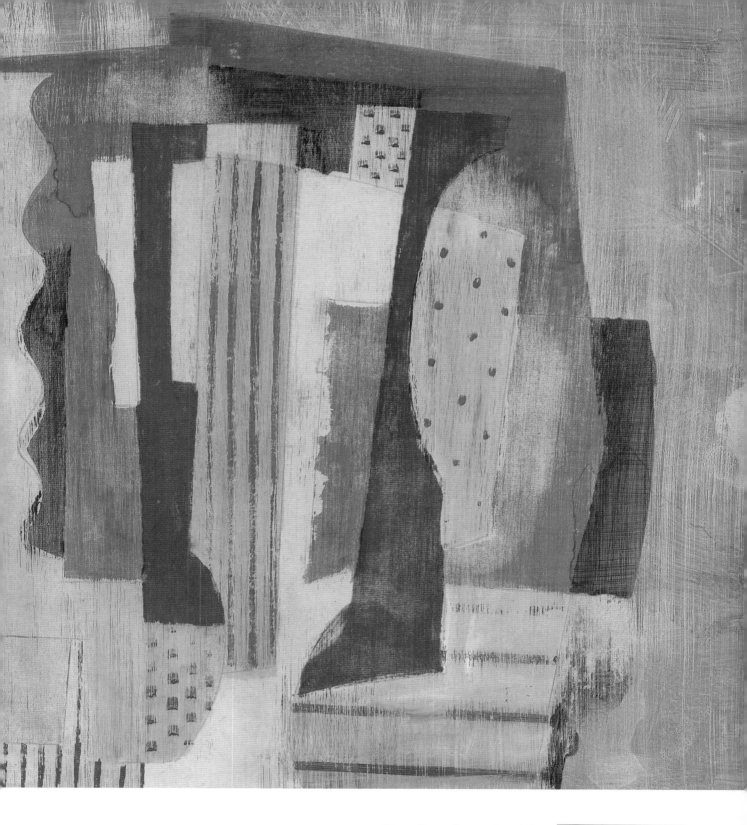

When the colours of a picture
become too strong, there is nothing to stop
the artist taking the surface off. In this
Synthetic Cubist gouache, this has been done with
a household scrubbing brush. The scrubbing brush
has not been named in the list of materials on
pages 28–44 and 81, but any object or means can
be brought into use if the need arises

PERSPECTIVE

The painter of abstract pictures may use perspective or not as he or she pleases. If solid shapes are wanted which are set in space, where it is felt that you can visualise what is behind and what is in front of them, then the use of perspective is a must. Perspective is the device which bemuses the eye into thinking that a flat object on a piece of paper is three dimensional.

The ancient Romans knew about perspective and used it well and frequently in their wall paintings, but when they disappeared from the scene it was hundreds of years before painters got the hang of it again, and there were many false starts. But those artists who were very good at it made certain that they exploited it to the limits, and in doing so their pictures sometimes became blueprints rather than works of art.

The easiest way to understand about perspective is to go out and look around. A straight road going to the horizon seems to narrow, although

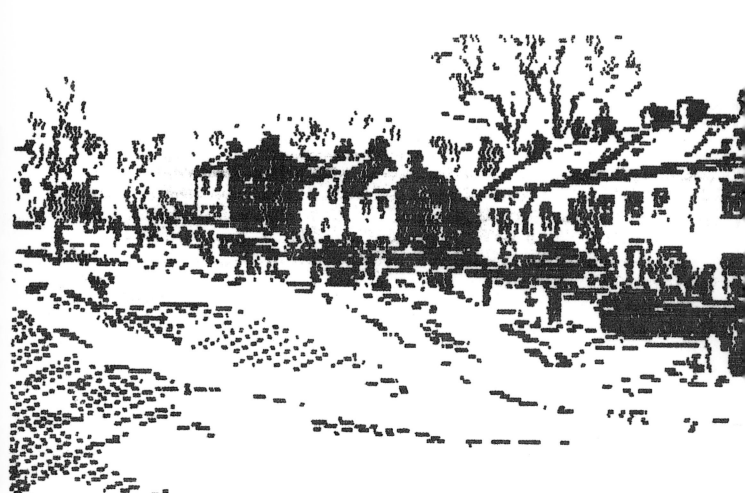

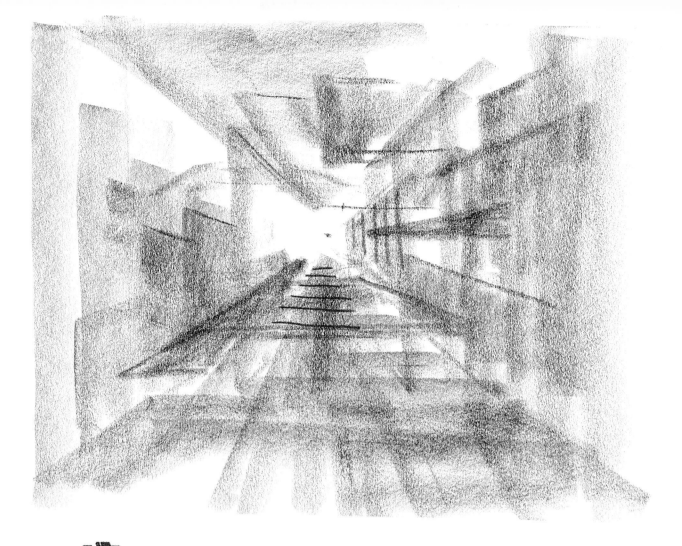

Above:
A painter of abstract pictures may use perspective or not as he or she pleases

Left:
Perspective is well illustrated in this computer sketch of cottages, roofs going down to the eye level, the bottoms of the cottages going up. Use of perspective here clearly indicates that the ground is rising towards the further cottages

we know that it doesn't narrow; and a person walking down this road appears to be shorter and slimmer as he moves away. Moreover this reduction in size is at a fixed rate – and if the road reaches the horizon the sides will meet at what is known as the vanishing point on the horizon.

What is the horizon? It might be supposed that it is just the place where land and sky meet. But if a person is standing in front of the Alps and looks up at the top of the mountains, is that the horizon? The answer, quite simply, is 'no'. The horizon is always at eye level, and has nothing to do with the sky line. The only place to observe a true horizon is at sea, where the sky meets the water.

The horizon is purely a terrestrial phenomenon. Travellers in space may see all kinds of effects, but not a horizon. If you sit down on the ground you will find that the horizon has moved; if you ascend to the top of a multi-storey building it will move again. The main use of the horizon to artists is that objects above it – that is, above the level of the eye (hold a pencil at arm's length to test it) – will appear to go down towards the horizon, and those below will go up.

The simplest way to appreciate this is to look at the roof of a house; or at the roofs of several houses, especially if they lie in a jumble, pitched this way and that. If the line of the single roof is extended it will go to the horizon; but the line of many roofs is not consecutive and each goes a different way. Furthermore, each individual roof has its own particular vanishing point, so although there is only one horizon, there are limitless numbers of vanishing points. Objects in a painting – if they are meant to be three-dimensional – obey the laws of perspective as a roof

Right:
Perspective can be suggested by setting pure colour and half-tones against a dark background, as in this oil painting of flowers by Sam Dodwell RI

Below:
Sometimes perspective is implied, as in Seascape in Raging Storm *by David Pearce, which has an almost Turneresque quality*

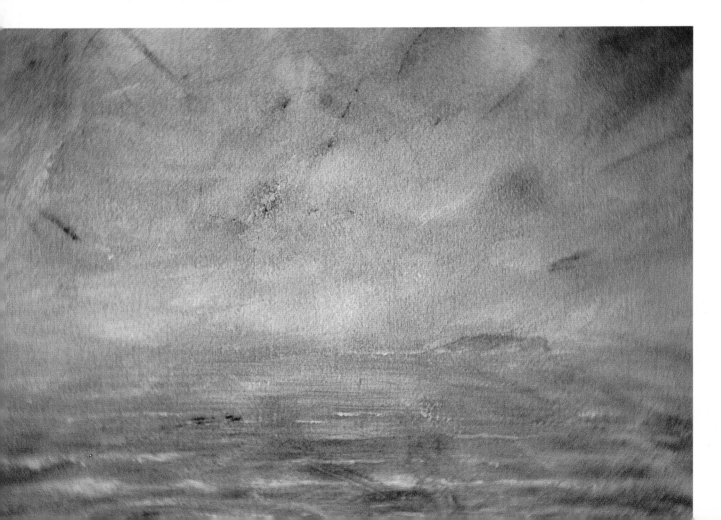

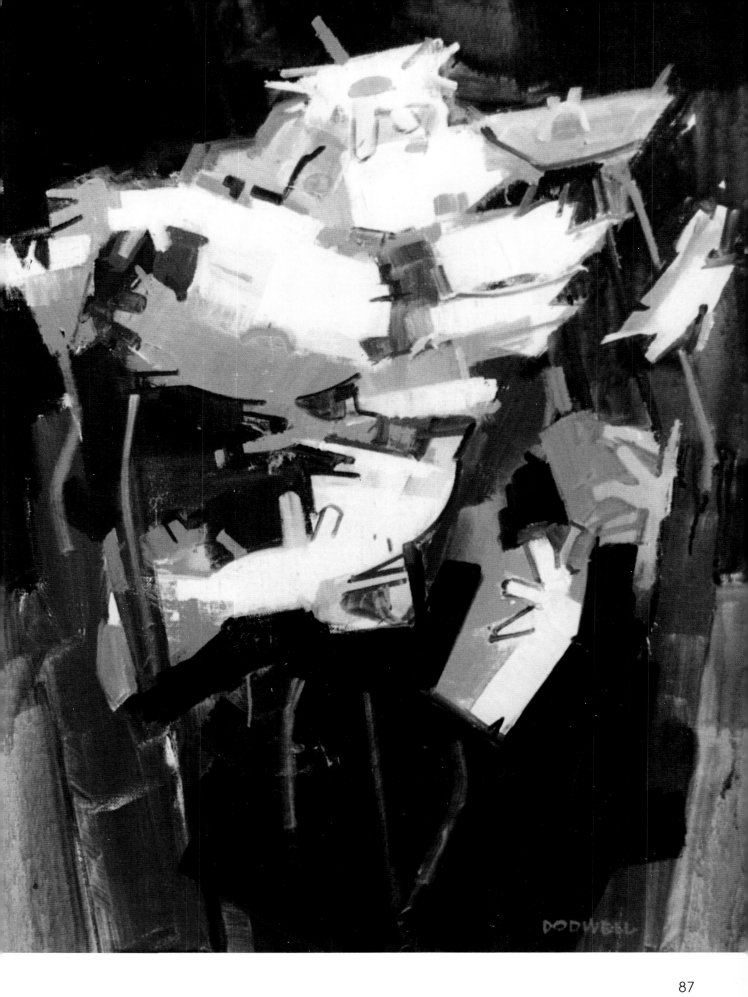

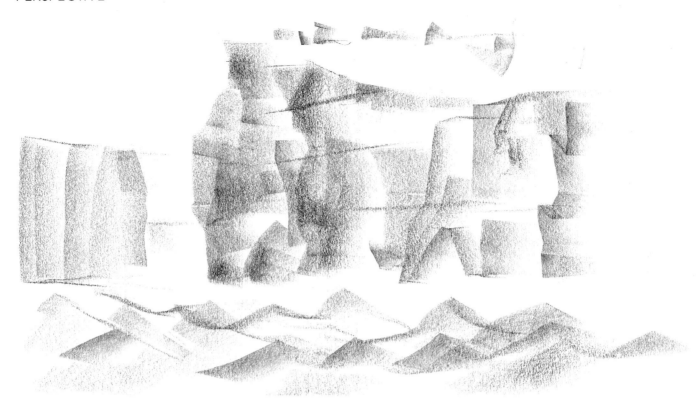

Above:
Recession can be indicated by overlapping
segments, as in this abstract cliff scene

. . . or this study of figures (below)

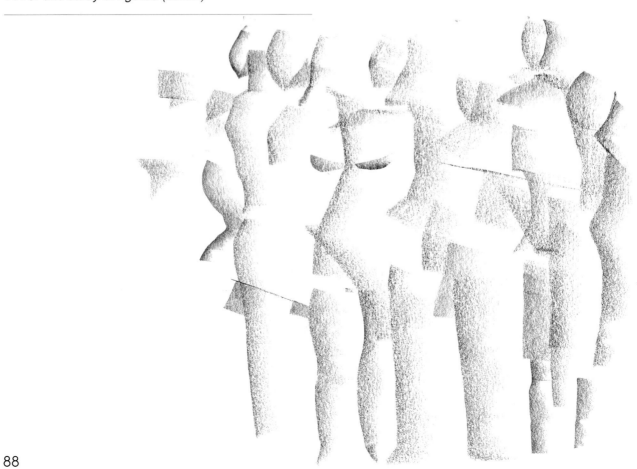

does. If the object is near the picture surface the angle with which it recedes will be sharper than the angle of something in the distance. And so the sharpness of the angles and the relative size establish the object's place in relation to other objects on the paper or canvas. Using perspective you get a sense of solidity and of recession; without it, you get a flat, front-on picture of the kind done by young children who have not yet been taught how to express the world out there, and put it down in pencil and paint. Children express not what they see, but what they know.

For abstract artists the horizon can be as high or as low as is wanted; it can be off the picture edge. But objects still recede towards it in accordance with the rules – except that the rules can be twisted, as they were with uncanny skill by the Surrealist painter Salvador Dali. There is nothing to stop an artist using more than one horizon in a picture; but multiple horizons can bemuse and muddle, become inconsequential and make the use of perspective pointless.

The experts in perspective drawing are not artists but architects and designers. If an artist's perspective looks right, that is sufficient. Asymmetric objects also obey the laws of perspective, and although it may seem a problem to get it right, once the artist gets the feel of putting things in space it turns out to be quite easy. Similarly, cylindrical or globular objects can be coped with,

even if they are placed at awkward angles so that a circle becomes an ellipse. If there are difficulties drawing an ellipse free-hand, use a pair of compasses, draw two arcs facing each other at a likely place, and join them together free-hand. No-one is going to give you a prize for being technically accurate – if it looks right, it is right, and it is not absolutely essential for abstract artists to observe such details as accidental vanishing points, or angular perspective ('corner-on' viewpoint), although an understanding of these may help to make a painting more effective.

For example, a surface which is tilted occasionally converges on an accidental vanishing point which is above or below the eye-line. The sides of a road going uphill will appear to meet at a point above the eye-level – if the hill was absent, they would converge at eye-level. So every neat theory has its exceptions. Try it out with a piece of square card tilted upwards and work out where the vanishing point is – or is not, as the case may be.

Aerial perspective can be used in abstract paintings, although it is more of a landscape

Below:
Perspective contrasting with flat 'face on' areas

Left:
Perspective occurs in everything.
Foreshortening is a feature of perspective,
as in this eighteenth-century drawing of a hand

Right:
A black silhouette against a background always
suggests recession. Winter Mission is an example
of how realism can be combined with abstraction.
The background is further 'receded' by flicking
granules of paint on the surface, using a toothbrush
and thumb. When this is carried out, areas which
you do not want to be affected should be masked
off using a piece of paper cut or torn to the right
shape

Below:
Objects in perspective, including Felix the Cat

device. It is a strange term, but actually all it means is the effect of distance and atmosphere on vision. Distant objects are diffused and obscured, lighter or higher in tone, and often take on a bluish tint. If they don't, landscape artists pretend that they do, for anything that is blue or blue-tinted recedes anyway, and a blur of blue in the distance can be amiably interpreted by the spectator as a tree, or a castle or a far-off town.

Abstract paintings using perspective can be very impressive, even startling, and can contain all kinds of optical tricks. Receding colours such as blues and yellows can be placed at the front, with the advancing colours such as red in the background. A huge scale can be suggested using sharp-angled perspective, and at all times perspective can be mocked by putting in something flat, parallel with the picture surface. Never forget that in all painting there is an element of trickery.

• •

I would say that there is no real contradiction between art, conceived as design, and the unconscious. The unconscious does, in fact reveal design. Not only is the dream, when understood, a dramatic unity, but even in its plastic manifestations the unconscious possesses a principle of organization.

Herbert Read 1944

• •

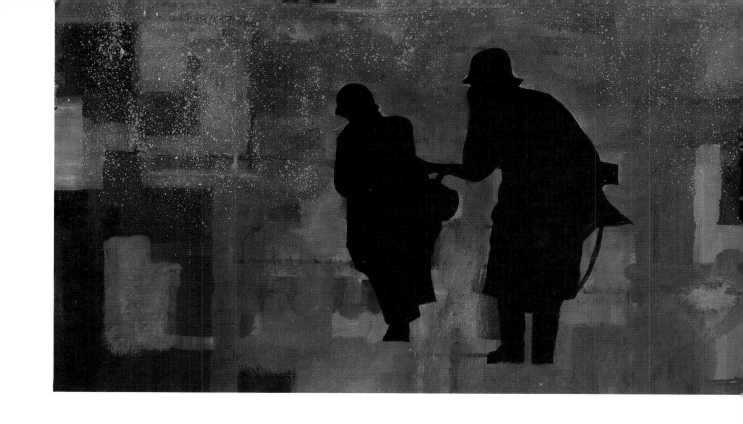

PERSPECTIVE
PROJECTS

*A simple drawing
showing perspective, with all objects
receding to one vanishing point*

*The same drawing
with additional elliptical shapes and
two contradictory − ie they are not on the
same eye-level − vanishing points*

*A third vanishing point
is added, so that the effect of perspective
is almost lost, though there is an
additional design element*

Above:
A picture using a series of boxes of different sizes, each one receding to its own vanishing point in the exact centre. Although it gives the effect of a waffle, such devices can be very effective, particularly in colour

Below:
A series of boxes and shapes set in a 'broken' format, with two black circles face on to the viewer, showing how such flat shapes form a sharp contrast with any background perspective drawing

DRAWING

Abstract painters will not necessarily be interested in drawing as a discipline, nor concerned with tone, shading, getting a likeness; but if they are engaged in doing a non-representational painting with a theme something linear may nevertheless need to be set down. This can be done with anything that makes a mark – pencil, charcoal, pen, pastel, crayon – and on any suitable surface. If you are not certain what you are going to do, but have one or two ideas on the brink of making their

appearance, help them on their way by some aimless doodling, ignoring passages that do not mean anything and concentrating on pencil marks, lines, or blotches that seem to be about to lead somewhere.

Do not bother about rubbing out superfluous work, unless you are meticulously working in watercolour where an under-drawing will show through. In most mediums it is simple enough to cover over the drawing which has been mentally discarded, leaving only the material you want to use. When working fast and trying out ideas, and especially if working on a fairly large scale, it can be advantageous not to hold the pen or pencil in the normal way, gripped between the thumb and index finger, but loosely, at the end, holding it between the thumb and four gently bunched fingers. Movement is then freely from the wrist, and it is an ideal way to draw circles or arcs.

If you are painting an abstract picture you may not be interested in drawing as such, only in providing a shape to be coloured or otherwise worked. It may be simpler to take short cuts – copying or tracing.

Some people can copy free-hand, some cannot, and it is much easier to trace. There are several ways of reproducing a picture onto a surface, and there are two distinct ways of tracing. The first is using tracing paper, bought from stationers and art shops usually in a pad – never use substitutes such as tissue paper or thin bank paper. The image is then transferred to the working surface using carbon paper, or by pressing hard on the design with a sharp pencil or tool

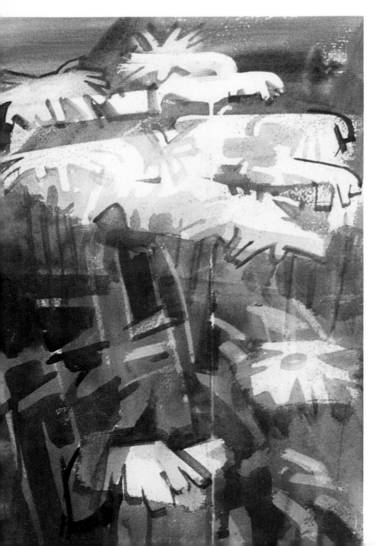

*In this flower painting in watercolour
by Sam Dodwell RI, the drawing is done with
the tip of a sable brush*

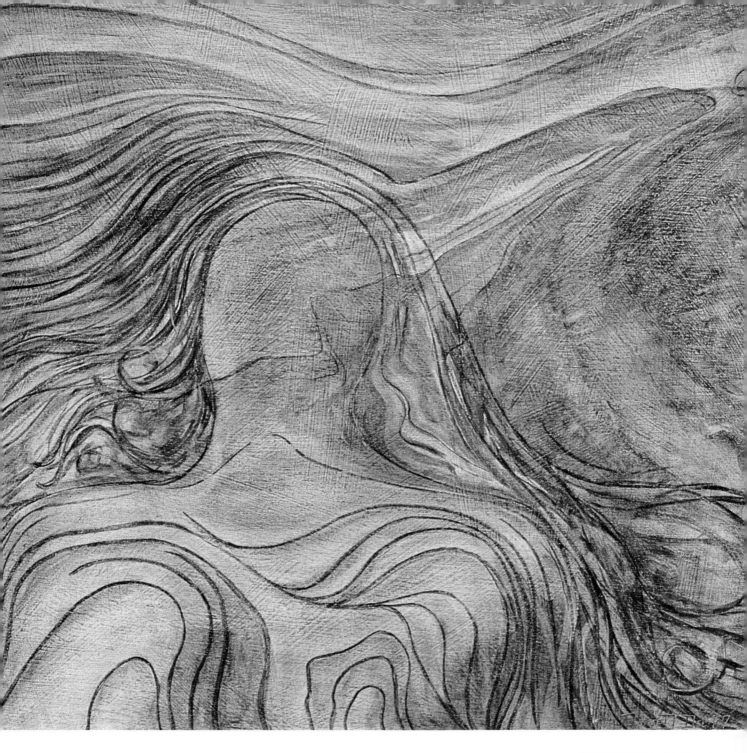

so that the paper is indented. These grooves can then be carefully gone over with a pencil.

The second is to use carbon paper directly. This is when you want to make use of newspaper, periodical or magazine photographs; they should not be of value, nor be too thick, and can be stored for possible future use. For carbon copying, black-and-white originals are better than colour. Use black carbon paper and a very sharp pencil no softer than HB, and decide beforehand what you are going to put in — whether just the outline, or the details as well. The image on the

Beauty in Time by David Pearce,
in charcoal and acrylic. Notice the ease
and freedom with which the curved lines are drawn

paper will be as clear and precise as if it were done with pencil or pen. This kind of copying can only be done on a smoothish surface; if on canvas, the surface must be primed until there is little texture.

There are other methods available to transfer photographic images such as the episcope, a

device that projects a picture onto a screen or wall – or the paper or canvas – by means of a grouping of mirrors and a strong internal lamp. The image is then drawn, even painted, as it is projected onto the paper or canvas; this method is favoured by painters of the magic realism school, whose pictures are often mistaken for colour photographs. The second method is by using a slide projector, but this is more restrictive as the slides have to be made first, and there is not the immense amount of outside visual material available.

Yet another method is to use a pantograph, where originals can be copied larger or smaller. The pantograph is a system of folding and jointed wooden struts with a pointer to follow the lines of the original drawing and a pencil at the opposite end of the device which follows the lines of the pointer – the same size, or smaller, or larger. The cheap plastic ones are worse than useless, and the more expensive ones do not live up to their expectations.

Of course, there is nothing to stop an abstract painter using meticulously realistic drawings as a basis. In this case we forget stylisation, copying, and look at objects as they appear, not as we

An outline drawing of a stool

Note how it gains solidity by the use of shadow. An outline is only a convention

Left:
When drawing the face – or indeed anything – it is important to put down what you see, not what you know is there. The lower lip here is indicated purely by the shadow beneath it. If transposed onto a separate piece of paper, the eyes would be meaningless, a random selection of blotches

Below:
An 'abstract' of the drawing, turning it into a pattern of shapes, a possible basis for a non-representational picture

know they are – and the simplest way this distinction can be made is to look at young children's drawings. A circle with two blobs, a vertical stroke, and a crescent shape beneath them is a face. To children there is no doubt about it; it is a convention sometimes used by artists such as Paul Klee. In fact, children are engaged in a type of abstract painting – they put in an outline and colour bits inside, and an adult without any kind of art training will do the same thing.

But an *outline* as such does not exist in life; it is rather a division between an area of light and an area somewhat darker. In drawing, an actual line has to be used, because we are trying to depict a three-dimensional object in terms of two dimensions, and for realistic drawing an outline has to be associated with tone.

Abstract painters working in three-dimensional shapes do use tone. Different colours do not depict tone, though they may represent it. Putting down in pencil what we are seeing does not depend on cleverness and manual dexterity; it depends on looking and assessing, observing how certain shapes relate to each other. Sometimes these shapes can be simple (like a barn in a field), sometimes complex (such as the turn of

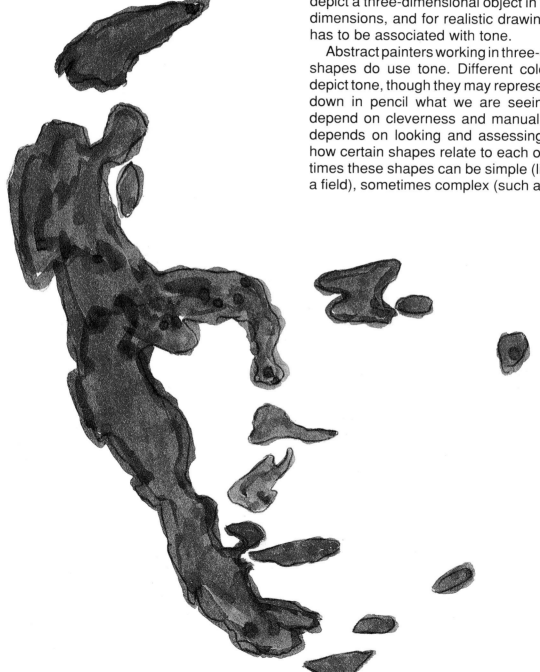

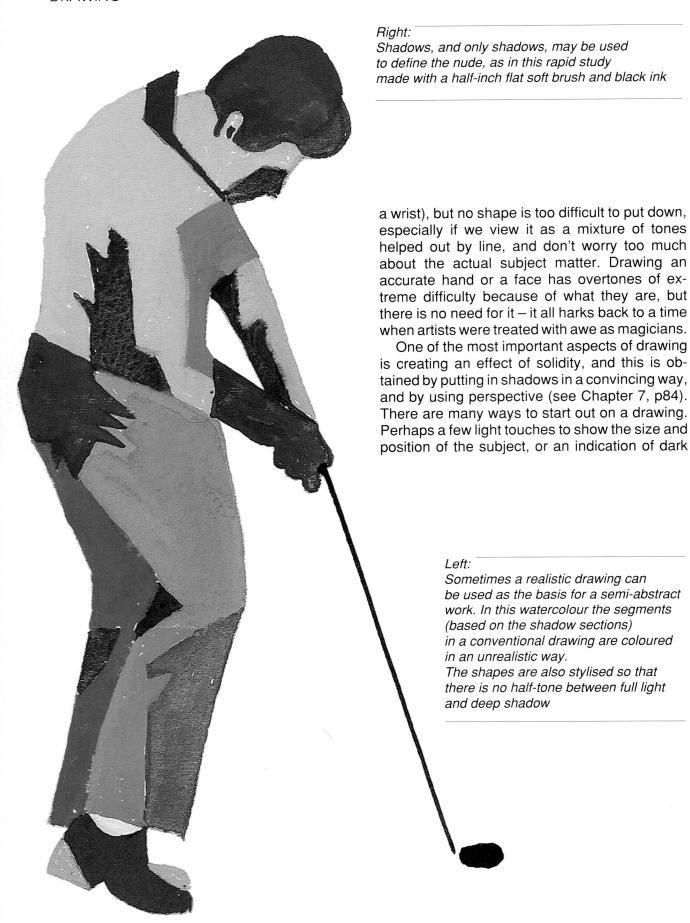

Right:
*Shadows, and only shadows, may be used
to define the nude, as in this rapid study
made with a half-inch flat soft brush and black ink*

a wrist), but no shape is too difficult to put down, especially if we view it as a mixture of tones helped out by line, and don't worry too much about the actual subject matter. Drawing an accurate hand or a face has overtones of extreme difficulty because of what they are, but there is no need for it – it all harks back to a time when artists were treated with awe as magicians.

One of the most important aspects of drawing is creating an effect of solidity, and this is obtained by putting in shadows in a convincing way, and by using perspective (see Chapter 7, p84). There are many ways to start out on a drawing. Perhaps a few light touches to show the size and position of the subject, or an indication of dark

Left:
*Sometimes a realistic drawing can
be used as the basis for a semi-abstract
work. In this watercolour the segments
(based on the shadow sections)
in a conventional drawing are coloured
in an unrealistic way.
The shapes are also stylised so that
there is no half-tone between full light
and deep shadow*

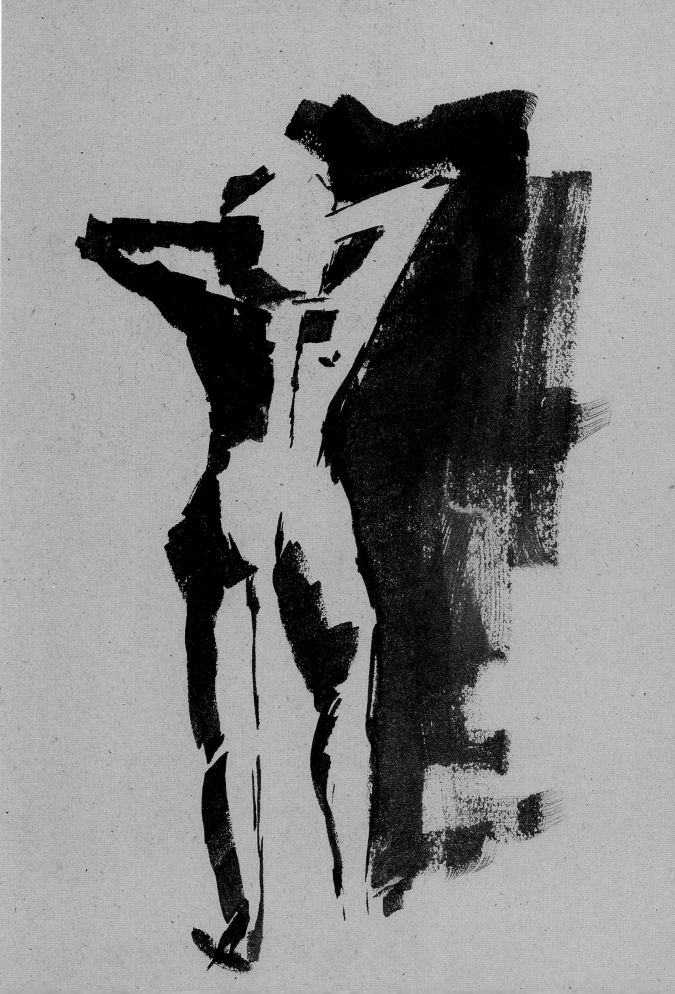

areas by using a stick of charcoal or pastel on its side, building up with tentative lines as you begin working it out. These can be firmer when you know that you are on the right track.

Shadows are not just shadows – there are many varieties of them which are not really observed in everyday life. Some shadows arise from part of the object being away from the light source. There are background shadows, where the object is in the light and the background is not. And there are cast shadows, in which one object or part of an object is blotting out the light from something else. For example, if we look at a complex flower such as a hyacinth we see how the various units comprising the flower-head influence adjacent units by overshadowing them. Cast shadows are darker than other shadows.

A circular object in a good light – such as an orange – is a good way to get to grips with shadows. Notice how the tone graduates in the part away from the light, and be sure you realise that this has nothing to do with a colour change. Shadows can be indicated in any number of ways: 'hatching', a series of close diagonal strokes; 'cross-hatching', diagonal strokes right to left then left to right creating a tiny mesh; dots

Above:
Drawing does not inevitably involve
a continuous line. In this two-minute pastel nude the
necessary drawing is carried out using both black
and white pastel

Right:
A cartoon from 1929. The problems of portraiture

● ●

The test of an abstract picture, for me, is not my first reaction to it, but how long I can stand it hanging on the wall of a room where I am living. A bad, or an imitative design becomes unbearable.

John Betjeman 1948

● ●

Portrait Painter. "I KNOW YOU'RE GOING TO SAY THERE'S SOMETHING WRONG WITH THE EYES."
Loyal Wife. "MY DEAR, I THINK THEY'RE MARVELLOUS—EACH IN ITS OWN WAY."

(close together for very dark, less close together for the half-tones); scribbles; or put in with charcoal or a chisel-pointed pencil in solid black.

All objects to be drawn are 'out there'. They can be set up, as in a still life with a collection of household objects such as fruit, bottles, and jugs; or they can be 'found', as in a landscape or townscape, but they are all subject to the same physical rules. And once a newcomer has got out of the habit of seeing in outlines, there is the question of proportion, drawing things which are the right size in relation to other components in the picture. Sometimes the difficulties are due to a lack of observation. If asked to draw a face, most people, even if they are skilled enough to put in features, will start off by making the cardinal error of putting the eyes far too high in the head. In fact, the eyes are halfway down between the top of the head and the bottom of the chin.

Sometimes it is difficult even for an experienced artist to relate the dimensions of one object to those of another. When this happens the simplest way to make a comparison is to hold the thumb at arm's length, and use it as a gauge. Such-and-such is a thumb-nail tall; and the other object is a knuckle-to-the-top-of-the-nail. For those who prefer, a 12in (30cm) rule can be used. An outstretched arm is a perfect mechanism; it is always the same length, and pivots easily at the shoulder.

In realistic drawing it is easy to make assumptions that are not true, and it is important to sort out in the mind what you are seeing, and not what you imagine you are seeing. In a landscape sketch, for example, the leaves of a tree in the middle distance may be painstakingly inserted one by one – despite the fact that from that distance all the viewer sees, even with perfect eyesight, is a cluster made up of different tones. The same with grass. Individual blades of grass can only be picked out in the foreground; otherwise it is identifiable simply by different tones, darker where the ground drops and the light source is partly obstructed.

Drawing and sketching does not have to be a life-time's work, and if you are absolutely taken up with painting abstract pictures it may be a skill which is not needed at all. But it can be a fascinating side-line, a test of ability, a training in observation, and it can be very companionable. Attending life classes is ridiculously cheap and very enjoyable, and as most of those attending are amateurs too, the newcomer should not feel

A fully worked-out portrait expressed in shadows without lines at all

overawed. Drawing a nude is no different to drawing a bottle or an apple, except that there is a time limit because a person cannot keep endlessly immobile.

Even the process is similar – putting down a few lines to determine positions and proportions, filling in areas of shadow, projecting tentative lines and building on them. Some artists start with the eye, setting in the nose and mouth, building up the face bit by bit. Some start with the background shadows, fixing the figure against these, adjusting a bit of black there, adding a shadow here. Others start with the torso, building up from a solid centre. Perhaps one or two start with the extremities, the toes or the fingers, but not many if they have any sense.

Some newcomers to sketching are reluctant to go out with a sketch-pad and pencil, especially in these violent days. And they may feel shy, feeling that an artist sketching a view is fair game to sightseers, nosy-parkers, and the self-opinion-

A drawing of a tree treated
in an abstract manner. The surface texture of
this watercolour is speckled, using paint flicked
onto the paper with a toothbrush

ated who know what they like and don't mind who knows it. If you want to go sketching without outside interference, go out in a car and draw from the inside of the car, with the windows down if you feel like it. Or join a sketching club, where there will be good and bad artists, and no-one who will level personal criticism.

This may all seem irrelevant to abstract painting. But really it is not. For by going out and really looking at something, rather than just noticing it, the artist builds up a stock of visual memories that can be transformed into something else. For when sketching something, the whole attention is concentrated on that object, and the object takes on a peculiar importance of its own, as though isolated and made special.

GOLFER PROJECT

*An outline drawing of a golfer.
This can be done freehand, using tracing
paper and carbon, or using carbon paper*

*Duplicating the golfer in
mirror fashion. This can be done by
making a tracing of the original drawing,
turning the tracing paper over, and
making a new drawing, either using
carbon paper or pressing down hard on a
sharp-pointed pencil, leaving
indentations in the surface which can be
gone over with a pencil.
Where the two golf-club heads intersect,
one club head has been taken out, the
reason being to keep the two figures
'apart'*

*The next stage is to break
up the picture surface by introducing
open shapes with a view to filling them in
and making a pattern*

continued overleaf:

Extra horizontal shapes are introduced, which can be interpreted as bunkers, background grassland or foliage, and (in the top right-hand corner) a cloud form. Or the shapes can simply be regarded as patches of colour and design. Where the shapes meet other shapes, the intersections form a demarkation line for the colouring

Because the design seems to be building up in the top half of the picture, further horizontal jagged shapes are placed at the bottom of the picture to act as a counter-balance (which may be interpreted as the foreground). Some of the colouring of these shapes is allowed to spread outside the shapes. Also added is a filled-in circle in top-right corner, perhaps indicating a sun, and to balance this a larger circle is placed diagonally opposite, perhaps indicating a golf ball. These, plus the three-coloured post on the right of the picture keep the design penned in. Three flags are put in in decreasing heights to give a hint of perspective leading back to a reference to a club house. This club house could be painted in bright colours to give an accent

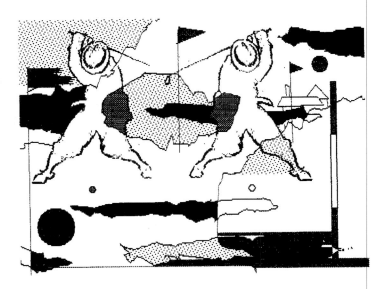

Following on from the feeling that the whole design is in danger of becoming top-heavy, the two golfers are lowered so that, if we start thinking in terms of perspective, they are in the forefront. Consequently the cloud formations are enlarged. The horizontal shapes at the bottom of the picture have now gone, and the dark shape between the two golfers has been removed. This kind of action – chopping and changing the whole design – can only be taken if the borders of the picture have not been set

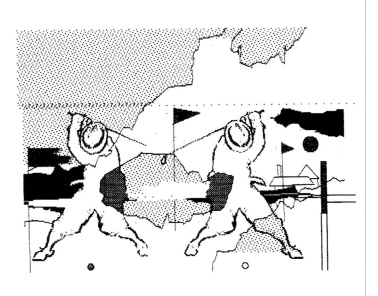

The next stage is building
up a sort of stylised landscape on what
might be termed the horizon, indicated
by horizontal lines. This part of the
picture, in the centre, is where the eye
is naturally drawn, for the buildings are
flanked not only by the two golfers
but the shafts of the golf clubs

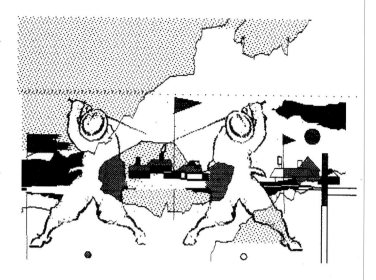

To show how a picture can
be radically altered at a late stage,
one of the golfers has been taken out
completely, opening up the background.
To provide accents small patches of
colour have been added near horizon
level and to compensate for the absence
of one of the golfers a small jagged
horizontal shape has been placed bottom
right-hand corner

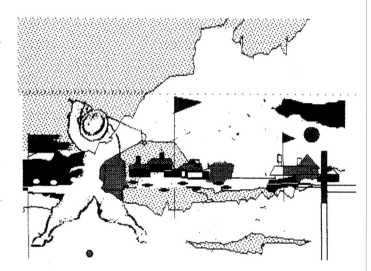

The left-hand part of the
golfer has been removed and the
right-hand part has been repeated,
forming a picture edge. A large black
'cloud' has been placed top left,
countered by a pair of dark shapes
bottom right. In addition small jagged
shapes perhaps suggesting birds have
been positioned in the open area to the
left of the 'cloud' on the right

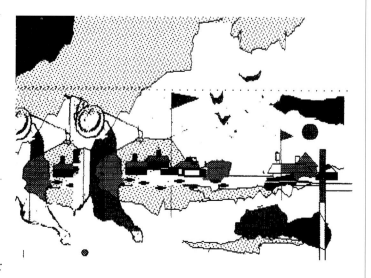

continued overleaf:

The golfer has now been taken out completely leaving a 'landscape'

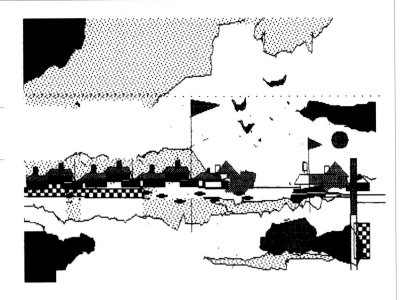

Turning a horizontal picture into a vertical picture by completely taking out the left-hand half

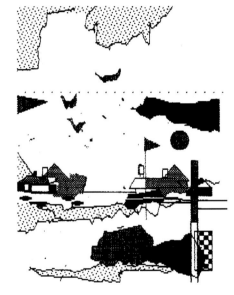

Not a mixture of media but a mixture of styles. An abstract painting does not have to be all of a piece, as shown by the introduction of a perfectly realistic golfer teeing off. The eye is drawn to this figure automatically by taking out the flag design in the centre of the picture, and the horizontal jagged edge bottom right acts as a pointer

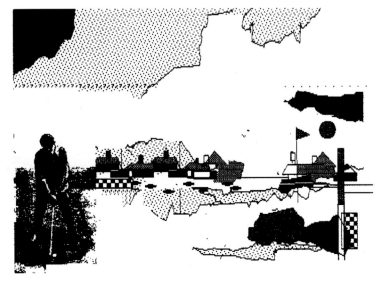

COLOUR SCHEMES

A question that soon arises no matter what type of art is to be carried out is: What colours should I get? The answer: Precisely those you want to use, may want to use, or which have an interesting name on the label. There is no set formula, least of all for abstract painting. Some abstract artists have been content with the primary colours of blue, red, and yellow, with black and white. Some, indeed, have managed with just black and white, working only in tones of grey.

However, it is worth looking at the colour schemes advised by writers on art, and as used by artists themselves. Abstract paintings do not

Woodworking Vice, *acrylic on bright red paper, demonstrates how under-colours affect those on top. Even though the white circle is laid on fairly thickly it is warmed by the red beneath*

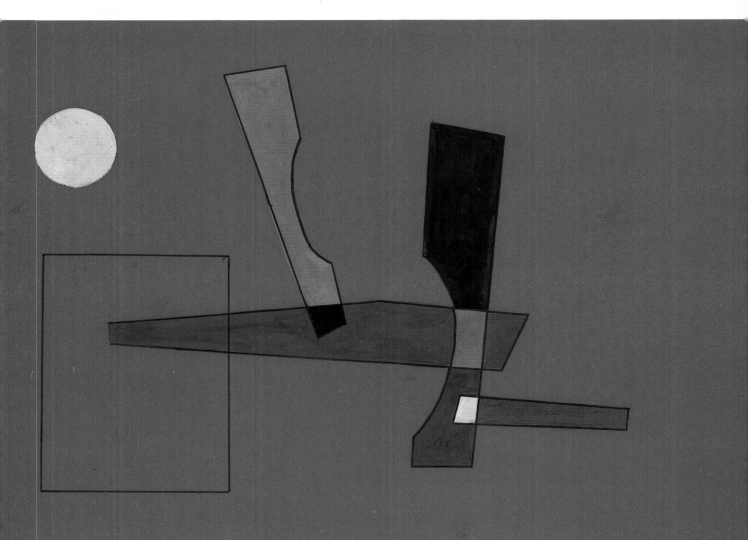

have to be stark and loud; they can be as subtle as you please, and many of the following colour schemes are worth considering.

Some of the palettes contain flake white. This is artists' quality white lead, and it was widely used before there was any clear idea that it was poisonous and potentially a very dangerous substance.

chrome lemon	ultramarine
yellow ochre	raw sienna
alizarin crimson	burnt sienna
light red	Vandyke brown
vermilion	viridian
Prussian blue	ivory black
cobalt blue	white

*A traditional watercolour palette.
The white is optional.*

ultramarine	indigo
yellow	rose madder
cadmium red	madder carmine
scarlet madder	black
yellow ochre	white
burnt sienna	

*Lord Leighton (1830-96),
a famous exponent of Victorian High Art, notorious
for his luscious nudes at the Royal Academy and a
marvellous technician.*

iron oxide red or vermilion	
a brown earth colour such as burnt sienna	
a blue/green	black
white	

*Jean Millet (1814-75) a painter of peasant scenes
in dull, drab colours, whose picture* The Angelus
*was once one of the most famous pictures in the
world. He and his school were known as The
Dismals. Sometimes he did add brighter colours to
this array, so it was not all gloom.*

Ah, the critics!

ASPECTS OF MODERN ART.

PRESS DAY AT THE FIRST EXHIBITION OF THE "EXPLOSIONIST GROUP."

First Critic. "I DON'T QUITE SEE WHAT THEY'RE TRYING TO DO, BUT THERE OUGHT TO BE GOOD COPY IN IT IF WE COULD GET UP AN ARGUMENT."

Second Critic. "SO I THINK. LOOK HERE—I'LL TOSS YOU WHICH SIDES WE TAKE."

Above:

Of all the abstract painters who flourished in the pre-Stalin period of revolutionary Russia, perhaps the most important and influential is Kasimir Malevich who took abstract painting to its absolute limit with his painting of a white square on a white background (yes, that doesn't present many difficulties). Is the value of abstract paintings dependent more on the conception than the finished product? Is there a deep meaning in a white square on a white background?

Many thousands of words have been devoted to this, each word being in several syllables, but we will not be attempting to answer the question here.

This is an illustration in a rare book called Suprematism 34 *which sold in 1988 for £55,000*

Below:

This is the same picture with extra rectangles and lines added. How does this alter it? Do the extra elements destroy the value of the work?

If Malevich had put them in, would the picture have been accepted or rejected as the last word in banality? Is the value of an abstract painting dependent on what the artist thinks about it, or what a critic thinks? 'I could do that', the reader may say, 'it doesn't involve difficult drawing, abstruse colour, imponderable techniques. And I wouldn't expect £55,000, even if I had to do a book of them.'

The point of this book is that everyone can be an abstract painter. If you believe that you have got a good picture, you may have got a good picture

Above:
Blues, purples and reds in combination

Below:
Yellow is used dramatically in this painting by
Rebecca Roberts

ivory black yellow ochre
vermilion flake white
Prussian blue

*L.S. Lowry, the celebrated painter of matchstick
figures in industrial backgrounds; Lowry used his
paints directly from the tube, without thinning.*

Above:
As in most of his work, this collage by Roy Ray is
distinguished by an extremely subtle sense of
colour

Below:
This is a complex picture in browns, made dramatic
by introducing 'stabs' of blue and red

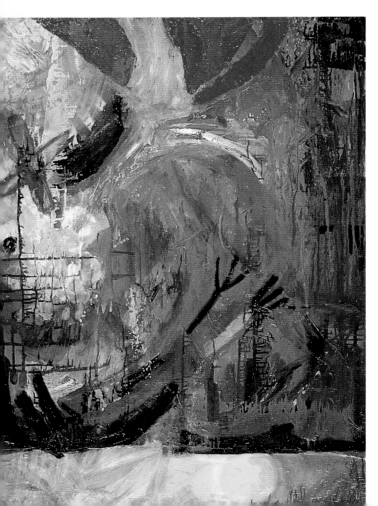

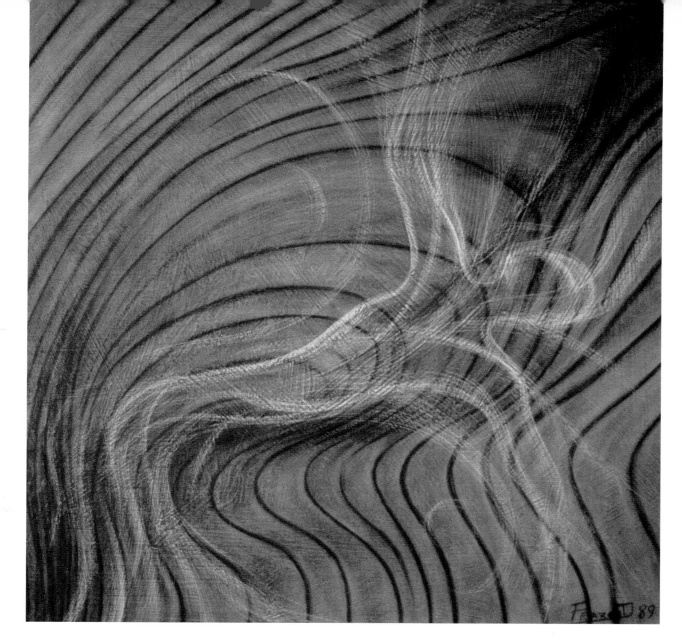

The prominent tones in
Reclining Nude *by David Pearce are blue-grey, a scheme which gives a certain repose and stillness*

light red	viridian
yellow ochre	raw sienna
cyanine blue	ultramarine
ivory black	auredin
burnt sienna	rose madder

A.W. Rich, writer on art and art techniques.

lead white	yellow ochre
ultramarine	red ochre
madder lake	orpiment
burnt sienna	ivory black
malachite green	

*Titian (1477-1576), great Venetian painter.
As lead white is now known to be poisonous it is surprising he lived to ninety-nine, as he used a lot of it. You won't find malachite green in every schoolchildren's paint box.
Nor orpiment, which is a gold.*

brown	red ochre
madder	terre verte
ultramarine	orpiment
yellow ochre	peach black

Hubert van Eyck (1370-1426) and Jan van Eyck (1389-1440), Flemish pioneers in oil painting, using not the pigments they wanted but those they could obtain.

111

lead white ultramarine
orpiment cobalt blue
yellow ochre terre verte
yellow lake malachite green
madder burnt sienna
vermilion ivory black
red ochre

Peter Paul Rubens (1577-1640).

flake white alizarin red
Naples yellow viridian
chrome yellow emerald green
cobalt, or ultramarine vermilion

*Firmin Auguste Renoir (1841-1919),
the great Impressionist artist. At this time Renoir
was apparently not using black.
Notice the inclusion of two yellows; for some
unknown reason Naples yellow is frowned upon
today.*

titanium white cobalt blue
yellow ochre ultramarine
light red

*A low-toned palette by Hilaire Hiler, author of
The Painter's Pocket Book (1937).*

lead white cobalt blue
red lake cobalt violet
vermilion emerald green
cadmium yellow viridian
ultramarine

an earth colour, maybe burnt or raw sienna

*Vincent van Gogh (1853-90),
everybody's friend whose* Sunflowers *became
the most expensive painting in the world,
and demonstrated that modern art could
be 'like'. Though of course it is not modern art,
being painted well over
a hundred years ago.*

titanium white cadmium red
cadmium yellow lamp black
ultramarine

A high-tone palette by Hilaire Hiler.

Venetian or light red raw sienna
medium cadmium burnt umber
ultramarine chromium oxide
lamp black (yellow)
zinc white madder lake

*A scheme of guaranteed permanent colours
by a pre-World War II chemist
named Toch.*

flake white ultramarine
pale cadmium yellow emerald green
vermilion Vandyke brown
rose madder black

*P.G. Hamerton (1834-94)
an engraver and writer on art. This is a typical
middle-of-the-road Victorian palette of 1876.*

French ultramarine cadmium orange
cobalt gamboge
turquoise brown madder
alizarin crimson burnt sienna
scarlet vermilion emerald green
yellow ochre viridian

*Mary Holden Bird,
watercolour artist writing in 1953.*

Most of these colours are available today, plus dozens of new ones created by modern technology, including the range derived from coal tar. Modern ultramarine is a substitute because the original was made from lapus lazuli, which fifty years ago cost more than a pound a small tray – multiply by twenty to get today's equivalent. Every painter will in due course evolve his or her own colour scheme, and will *ignore* advice not to use this or that even if it seems sensible. 'Outsider' colours such as sap green are disdainfully termed 'fancy' colours, and some of us will go out of our way to use them.

In tune with modern advertising there is a fashion for modern pigments to be given more saleable names, and as the colour on the label or tube cap rarely matches the paint inside, there is room for a good deal of harmless adventure.

For those who are determined that their pictures are going to last five hundred years without marked colour fading, here is a list of chemically disapproved oil colours, officially termed 'inferior and obsolete'. Most of us will continue to use them because we like them, or like the sound of their names. Turner used colours that cause purists to throw up their hands in disgust; his pictures have undergone a colour change. But maybe his colours have actually improved with the years; nobody knows, as the only evidence is hand-coloured prints.

REDS

Harrison red	lac
lithol red	crimson lake
scarlet lake	Venetian red
geranium lake	dragon's blood
para red	logwood
cochineal	Brazil wood
carmine	bole

BLUES

smalt	azurite
Egyptian blue	indigo
bice	Prussian blue

GREENS

emerald green	malachite
verdigris	chrome green
green bice	

YELLOWS

chrome yellow	Dutch pink
chrome orange	Stil-de-grain
Indian yellow	zinc yellow
gamboge	barium yellow
yellow lake	

BROWNS

Vandyke brown	bistre
sepia	asphaltum

COLOUR SCHEMES

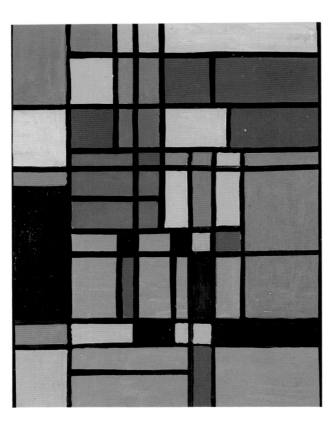

Left:
Widely diverse colours can be controlled by hemming them in with black lines. This is especially true of 'grid' paintings

Right:
Violet is a colour that may easily dominate a picture, but set against orange and lemon yellow it can form a pleasing contrast

Below right:
Underwater Scene, *using a matt background of black, blue and muted yellow. It is interesting to see how the colours of the various elements in this picture seem to change as they are set against the different background colours*

Below:
The background of blues and greys gives added emphasis to the various elements in the foreground in this picture entitled *Fragmentation*

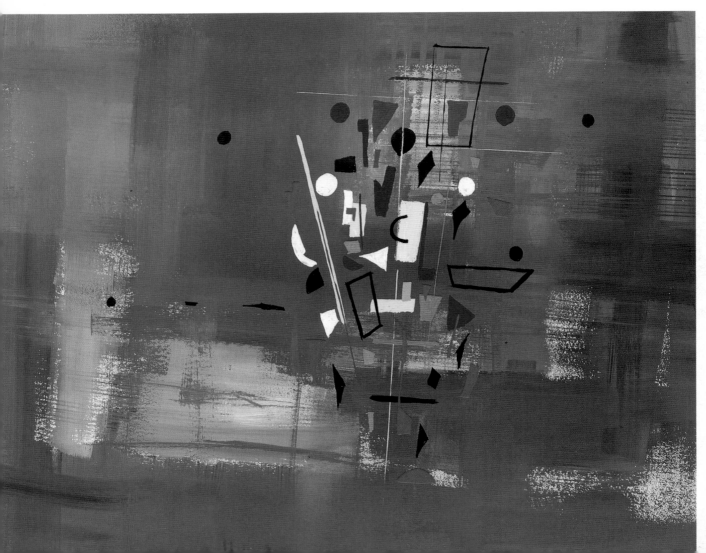

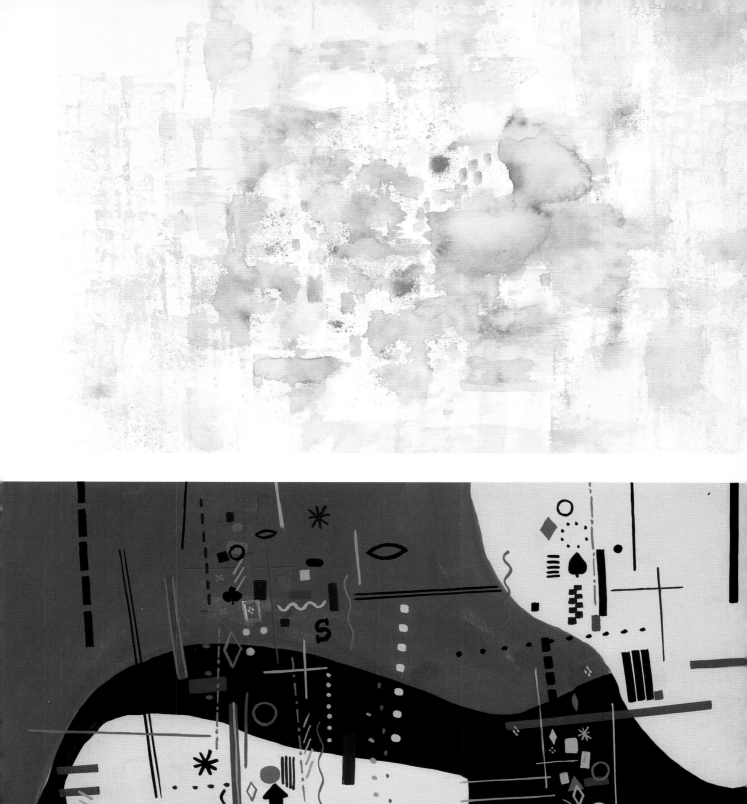

GRID PROJECT

*Stage one – putting in a grid.
This can establish where the elements
in the picture are to be set, and also
provide a guide when horizontals and
verticals are put in*

*Placing three circles,
so that they balance against the grid.
This balance is decided by the painter*

*Adding two triangles,
intersecting the circles*

*Introducing a horizontal
asymmetrical shape to provide a solid
middle section*

Adding a border

*If the design is too thin,
add further elements. A large circle
has been added, plus two jagged lines
at each side to centralise the design*

continued overleaf:

Colouring in the sections

*The same design
with different colouring showing
how the character of the picture
changes*

*Horizontals and verticals
in contrasting colours to give variety
to the picture surface and
provide accents*

Right:
*At any stage abstract
paintings can be drastically altered.
The circular shapes have been
replaced by angular shapes, and
triangles have been added. In doing
so the design has taken on a yachting
flavour, and small rectangles have
been added at the bases of the
triangles. These may suggest water
movement or yachting cabins*

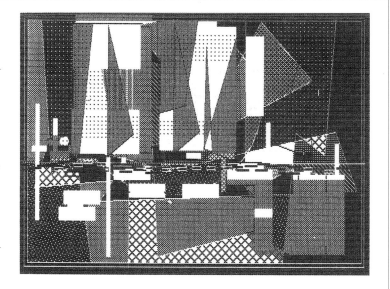

Below:
*Amplifying the 'yachting' theme by building up
the design and texture in the centre of the
picture and suggesting reflections. Of course this
is still an abstract picture, and
the yachts may not be apparent at all.*

*But it shows that not only can abstract pictures
start off by echoing or suggesting reality –
it can work the other way, too, and
pure geometric shapes can suggest
actual objects*

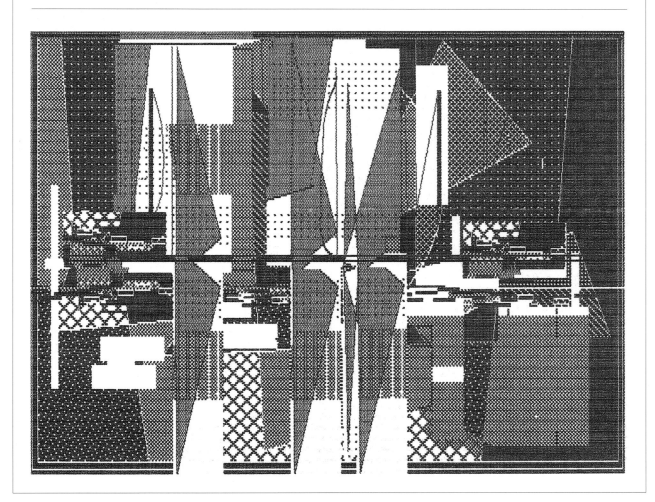

FRAMING

Mounting and framing a picture makes an enormous difference to its appeal, and if it is done well it does add a professional flourish. There is an undercurrent of feeling, rarely expressed, that a picture must have something about it if someone has bothered to frame it. Framing can be as cheap or as expensive as one wishes, and in many cases, the frame is worth far more than the picture. For example, mass-produced prints – framed – retail at up to £4, although the prints themselves can be bought for 5p -10p each from the suppliers, less if purchased in bulk.

It is usual to mount watercolours and put them in glazed frames, and much the same is true of gouaches and tempera. There is no such certainty about paintings in acrylic, for if they are thickly painted and varnished they look exactly like oils, and therefore should probably be framed like oils, in an open frame without glass. But there is no definite rule. Oil paintings, if of reasonable size, look splendid mounted and behind glass, and gouaches and tempera can be placed in open frames and look very well.

If you are going to have the job done professionally there is a wide choice of framers, but it is wise to shop around as there is intense competition and no accepted level of prices. One framer might do the job for £12, yet another who is no better, no worse, might charge £30. So get an estimate. A good framer will advise on the choice of a frame, and if it is a watercolour the best colour for a mount, and whether the watercolour should be surrounded by a line.

There is nothing difficult, however, about do-it-yourself framing. Picture frames can be picked up very cheaply, from less than a pound each, at boot fairs, jumble sales and in junk shops, the boot fair being the cheapest of the lot. If you are framing watercolours or gouaches do not be tempted to buy too many frames without glass. Glass is not expensive, but it has to be cut precisely to size by the retailer and in the end you can spend more money on the glass than on the frame.

If you buy a second-hand frame, clean it thoroughly, and if some of the moulding is missing but you think it might get by, be ruthless, and strip the wood down. The mouldings of old frames were made with gesso (plaster of Paris and glue) which dissolves in hot water, but it is easier to strip the frame down using an old kitchen knife and abrasives such as steel wool, finishing off with a plane.

If you buy an old frame with a picture in it, make certain that the picture itself is of no value before discarding it, if necessary asking advice. And take care when you are taking the picture out; it is not uncommon to find another one behind it. There will probably be brown paper pasted over the back to keep out dust; there is never much chance of using this again so throw it away, together with any wire or string used to hang the picture up, for although this may look all right it is likely to be weak and untrustworthy, and should be renewed using picture-hanging wire or nylon cord – but never ordinary string, as it dries out. When replacing hanging cords, do not use hooks but ring-screws (screws with eyelets).

Beneath the brown paper will be a backing-board; this may be a wooden panel or a piece of card, and may be reusable. If there are fragments of old backing paper sticking to the wood or card they should be removed.

Always clean the inside of a frame thoroughly, poking out any dust in the crevices, and then either paint the frame or sand it down, and perhaps varnish it. The colour of the frame can match the colours of the picture if required.

The accumulated filth of years may have built up on the glass and should be tackled with Windolene, detergent, and sometimes even a scrubbing brush. Flymarks – little specks of brown – may be resistant and need picking off with the blade of a sharp knife. When washed and dried, the glass should be placed on a sheet of white paper and examined carefully to make certain that it is perfectly clean.

The glass will have been held in by almost anything – brads, panel pins, drawing-pins, even strips of Sellotape, and old pins and tacks should be withdrawn with a pair of pincers and thrown away. Professional framers use a little gadget like a stapler which thrusts circular discs of steel into the side of the frame, and this is a great time-saver – though for the odd frame it is just as easy to go to the ironmonger's and buy a box of brads (short headless tacks as used by glaziers). There is no need to put dozens of tacks in when you are framing; three on short sides, four on long sides, is ample.

Large sheets of mounting board in a wide variety of colours are available from art shops, and have the mount too large rather than too small – a tiny picture can be transformed by setting it in a large mount. The mounting board must first of all be cut to fit in the frame, and at this stage you must decide if you want to show all the picture or allow the mount to overlap to a considerable degree.

Measure the picture side to side, making a note of the measurement; compare the measurement side to side of the mount, and divide the difference in two. Then working from the sides of the mount, put in your vertical lines. Work on the coloured show surface of the mounting board, for if you cut from underneath a ragged edge will show; and use a soft pencil which will easily rub out.

Then measure the painting from top to bottom, and then the board, divide the margin of difference in two and put in the horizontal lines. You will thus have a grid – it is better for the intersecting lines to overlap, as it is easier for cutting. When cutting the mount out, keep the steel rule still with fingers splayed out along the rule and away from the blade. Three or four lightish strokes with the knife are better than one hard thrust. If the mount is sticking, it will be because the corners have not been done properly; when it is cut it will drop out.

If you are putting lines round the mount aperture do it carefully, and if using a paint brush risks messing it up, put the lines in with a pastel pencil or a coloured pencil, or pen and ink. The brush should be a small point, and preferably a 'liner' which is made to do such jobs. In fact putting lines in can be an art in itself; sometimes the spaces between the lines are colour-washed in, but it is advisable to be simple rather than over-fussy. Of course there is no need to do any lining at all – a plain mount may be all that is necessary.

Frames made for oil paintings are deep so that they can house the canvas, but ordinary substantial frames intended for watercolours can be used if the painting is done on any surface other than canvas. Mouldings can be renovated if not too damaged by rebuilding with modelling paste and then gilding over; there is no need to use gold leaf, which is expensive. Goldfinger is a proprietory product in a tube and is admirable; it comes in several shades of gold and can be rubbed on with the finger tip or a soft cloth. It might seem dear, but a little goes a long way, and if a second-hand frame is more than usually intricate and there is hand-carving it might be valuable. Some antique frames fetch several hundred pounds each.

If the frame is too large for a specific purpose there is a temptation to cut it down, but the tiniest of errors will be compounded as an altered frame is reassembled. If the frame is too small, nothing can be done except to cut the picture down to fit. Some pictures can be trimmed, some cannot, and a canvas should never be cut down – though of course cardboard, card, canvas board and canvas paper can be.

Abstract paintings are rather different from traditional pictures which need to be displayed in an orthodox way, and there arises the question 'Why frame at all?' – why not establish the picture on a wall without a frame? Large and powerful images, especially, can make a tremendous impact unframed when they are well-positioned on an uncluttered wall. If the picture is painted on a canvas, two nails can be hammered horizontally into the wall, and the canvas lodged on them by means of the top of the stretcher. And a painting on card, cardboard, canvas paper or canvas board can be mounted on blockboard or fibreboard and fixed to a wall-hook by means of ring-screws attached to the back of the board. Many famous abstract paintings in national collections are not framed in any way.

Above:
*A painting of this type is usually
done on a large scale, and is often seen at its
best unframed*

Below:
*Green Embryo would be seen to advantage in a
large frame with a fairly dark mount
(perhaps olive green)*

Right:
Acrylics can be framed under glass or without glass, in the manner of oil paintings. This painting, Industrial Design, would perhaps benefit by being framed unglazed

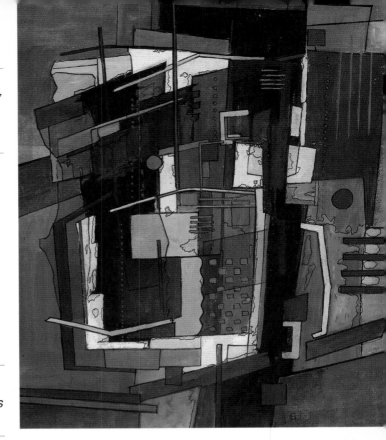

Below:
A mount can often serve to stop the elements in a picture 'leaking out'. A good colour of mount for this composition would be a pearly grey

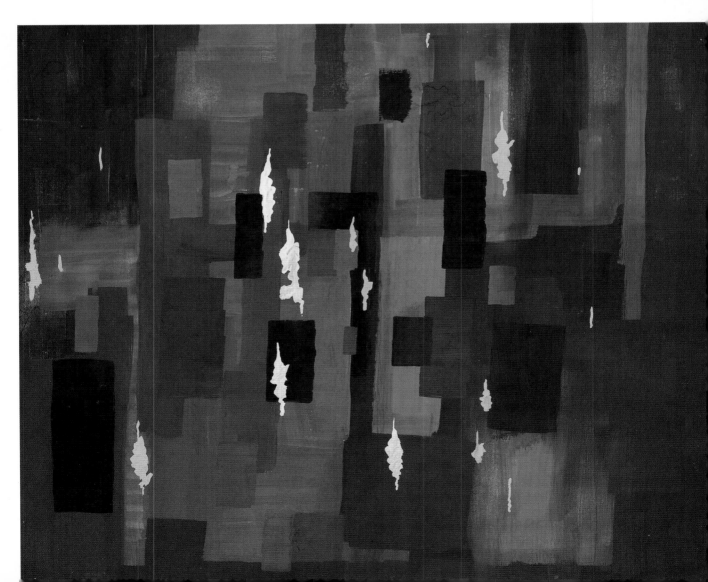

BIOGRAPHY
OF
ABSTRACT ARTISTS

This is a select, representative list. There are thousands of admirable abstract artists, many of whom have never been taken up. There are a considerable number – such as the great predominantly topographical artist, John Piper – who went through a short abstract phase, and there are others who did a few abstract paintings but were mainly concerned with abstract constructions and sculpture. There are many artists who carried on the traditions of Cubism, but were mainly concerned with prettifying it and making decorative pictures.

Becoming established is a matter of chance. A casual visit by an important if ignorant critic to a gallery can boost an artist's reputation overnight, whereas an exhibition in Wimbledon week may mean that an admirable artist is completely overlooked by those whose views matter. And alternatively, if an average artist is in the right place at the right time – as in Holland in the 1920s – he or she can be swept up in the enthusiasm and given an exaggerated rating. And an artist may be a better self-promoter than a painter, especially if using the correct jargon.

ALBERS, Albert Born Bottrop, Germany 1888, died New Haven, USA 1976. School teacher, then art training in Berlin, Munich, and at the Bauhaus, Weimar 1920-3. Taught in Germany and later in America. Painted cool geometric painting.

ARP, Jean Born Strasbourg 1887, died Basle 1966. Studied in Strasbourg, Paris and Weimar, moved to Switzerland 1909 and was involved in Dada and Surrealism from 1916. He moved to Paris, and was involved with collage, cut-paper and abstracts of an amorphous but clear-cut organic type, often brightly coloured.

ATKINSON, Lawrence Born Chorlton upon Medlock, near Manchester 1873, died Paris 1931. Studied and taught singing. As an artist self-taught, and from 1914 involved in the semi-abstract Vorticist movement. His paintings have a very Cubist feel. He was also a poet and a sculptor.

BALLA, Giacomo Born Turin 1871, died Rome 1958. Studied in Turin, moved to Rome 1895. In 1910 signed the Futurist manifesto, and began experimental painting glorifying the machine age and speed. In 1913 his Futurist paintings became more abstract and non-representational in tone. In 1930 he returned to more conventional work.

BIEDERMAN, Charles Born Cleveland, Ohio 1906, trained in commercial art 1922-6, fine art 1926-9. Abstract paintings and constructions from 1936, often brightly coloured and in novel materials such as aluminium.

BISSIER, Julius Born Freiburg, Germany 1893, died Ascona, Switzerland, 1965. Began as realistic painter, turned to abstraction, influenced by Chinese calligraphy, and his pictures may be described as simple-shapes-on-a-background.

BOCCIONI, Umberto Born Reggio Calabria, Italy, 1882, died Sorte near Verona, 1916. Associated with the Futurists, his work is akin in technique to the early ('analytical') Cubism of Braque and Picasso. In 1912 he turned to sculpture. He died falling form a horse.

BRAQUE, Georges Born Argenteuil-sur-Seine 1882, died Paris 1963. Trained as commercial painter and decorator, took to fine art 1902, and from 1908 evolved Cubism with Picasso, keeping with it and hardly diverging.

BURRI, Alberto Born Città di Castello, Italy 1915. A doctor in World War II, began painting as prisoner-of-war, exhibited from 1947. An abstruse style, neither geometric nor organic, but making pictorial equivalents of realistic subjects in low tone often using clotted colour. It is a type of abstract painting much favoured by modern British artists.

CARRA, Carlo Born Quargnento, Italy 1881, died Milan 1966. Joined Futurists 1910, wrote on art 1915, ventured into metaphysical painting after meeting Chirico in 1916. His early paintings are forms of analytical Cubism, very beguiling in colour.

DAVIS, Stuart Born Philadelphia 1894, died New York 1964. Worked in Paris 1928-9, and later in the USA did murals. His paintings are often a form of synthetic Cubism, flat decorative shapes, lucid, with easily understood themes.

DELAUNAY, Robert Born Paris 1885, died Montpellier 1941. Experimented with pure colour Cubism from 1912, a form named Orphism, at first with realistic echoes; later paintings were completely abstract.

DOESBURG, Theo Van Born Utrecht 1883, died Davos, Switzerland, 1931. Began as an Impressionist painter, joined with Mondrian to found *De Stijl* movement (pure geometry, coloured squares intersected by black lines) but less purist than his colleague and more versatile, involved in writing, lecturing, and architecture.

FRANCIS, Sam Born San Mateo, California 1923. Studied medicine and psychology. First one-man show 1952. The soft side of Abstract Expressionism.

GRIS, Juan Born Madrid 1887, died Boulogne 1927. Influenced by Braque and Picasso, he prettified Cubism, turning analysis into pattern-making and thus making it more accessible. The techniques were used for book illustrations and theatre sets.

HILTON, Roger Born Northwood, Middlesex 1911, died St Just, Cornwall 1975. First one-man show 1936. The Cornish landscape seen in abstract terms, evocative if sometimes obscure, and one of the 'unfinished look' school with scribbles and uneven patches of paint.

KANDINSKY, Vassily Born Moscow 1866, died Neuilly-sur-Seine 1944. Studied law and politics, exhibited from 1901, and his style, abstract from an early stage, changed from the wildly amorphic and organic to the crisp, the geometric, and the pretty on his return to Russia at the time of the Revolution. He lectured at the influential Bauhaus in Germany, and wrote much on art theory.

KELLY, Ellsworth Born Newburgh, New York 1923. Studied in Boston, lived in Paris 1948-54. Moved from 'chance' pictures – dropping torn paper onto a surface – to the opposite extreme, 'hard-edged' paintings using three colours or so. He was one of the main artists to use odd-shaped canvases.

KLEE, Paul Born Münchenbuchsee, Switzerland 1879, died Locarno 1940. Impossible to characterise. His works have affinities with children's art, the art of the unconscious, Expressionism, but in passing he painted many abstract pictures of great beauty and refinement and was one of the most succinct and persuasive theorists.

KLINE, Franz Born Wilkes-Barre, Pennsylvania 1910, died New York 1962. Trained in Boston and London, returning to New York in 1939. Noted for his broad, dashing black-on-white canvases in the calligraphic style, turning to colour in 1958.

KUPKA, Frank Born Opocno, Bohemia 1871, died Gife-sur-Yvette, near Paris 1957. First major exhibition 1912 in Paris, where his work – circles of intersecting colour – was akin to that of Delaunay.

LECK, Bart van der Born Utrecht 1876, died Blaricum 1958. An associate of Mondrian, but his paintings somewhat derivative and over-pretty, and he later reverted to realistic work.

LEGER, Fernand Born Argentan 1881, died Gife-sur-Yvette, near Paris 1955. Trained as a draughtsman, his paintings involve geometricising modern life – factories, machinery, people – often in a tubular form. His colours were bright, his subjects often edged in black. An example of an artist whose abstract paintings are never unambiguous and which always relate to life.

LISSITZKY, El Born Smolensk 1890, died Moscow, 1941. A key figure in Russian Revolutionary art and the movement known as Suprematism (he designed the first Russian flag). Worked in Holland with Mondrian and his school. His paintings are crisp, geometric, and always neat. He often used perspective, with elegant shapes set in space.

LOHSE, Richard Born Zürich 1902. A painter of bright geometric abstractions exhibiting from 1948 onwards.

LOUIS, Morris Born Baltimore 1912, died Washington 1962. First one-man show 1957. One of the first artists to use acrylic as a serious medium in abstract paintings, both expressionist and geometric.

LOEWENSBERG, Verena Born Zürich 1912. A disciple of Mondrian, and of open flat areas intersected by straight lines.

MALEVICH, Kasimir Born Kiev 1878, died Leningrad 1935. The most uncompromising of abstract painters, and with Mondrian perhaps the most important of them all. In 1919 he exhibited the ultimate in abstract paintings, a white-on-white square. A key figure in Suprematist (or Constructivist) art. He later turned back to figurative work as he thought that all that could be done with his type of pure abstract art had been accomplished (and he may have been right).

MARTIN, Agnes Born Maklin, Saskatchewan, Canada 1912. Moved to USA 1932, associated in the 1950s with the new men of American art. Her abstract canvases, where very little happens, are characterised by extreme subtlety and the faintest of tints.

MATHIEU, Georges Born Boulogne 1912. Studied law and philosophy, began painting 1942 and was one of the most important of the post-war École de Paris, vigorous and uncompromising, where the quality of the brush stroke is as important as the image.

MIRO, Joan Born Barcelona 1893, died Palma, Majorca 1983. First one-man show 1918, was associated with the Surrealist movement in the 1920s, and his curious squiggly creatures occupy the middle ground between figurative and abstract work.

MOHOLY-NAGY Born Bacsbarsod, Hungary 1895, died Chicago 1946. Involved in stage designs, experimental photography, and in abstract constructions. His work immaculate and neat, and he had a great influence on industrial design of all kinds. His geometrical paintings are very elegant, and make use of semi-transparent planes in space.

MONDRIAN, Piet Born Amersfoort, Holland 1872, died New York 1944. Began as an Impressionist, moved through Post-Impressionism, and in 1916-17 established the movement known as *Der Stijl*. His abstract paintings are pure geometry, mostly squares and rectangles intersected or bordered by thick black lines. Moved to London 1938, and to New York 1940, where his inimitable style became more frivolous.

MOTHERWELL, Robert Born Aberdeen, Washington, 1915. Studied art, philosophy, aesthetics, first one-man show New York 1944. Involved in the 'calligraphic' type of abstract painting, bold, intuitive, and basically monotone.

NEWMAN, Barnett Born New York 1905, and died New York 1970. One-man shows from 1950 onwards. Very minimalist paintings, often just a large tinted canvas enlivened by descending bands and stripes of colour.

NICHOLSON, Ben Born Denham, Buckinghamshire 1894, died Hampstead, London 1982. Son of the well-known painter William Nicholson. Experimented with Cubism, produced his first abstract work 1924, followed by painted reliefs. His abstracts often have references to the outside world, especially Cornwall where he lived for many years. The most cultivated and refined of the British abstract painters.

NOLAND, Kenneth Born Ashville, North Carolina 1924. First one-man show Paris 1949. A pioneer in hard-edge geometric abstraction on shaped canvases.

OLITSKI, Jules Born Gomel, Russia 1922. Studied art in Paris and New York, and in 1960 ventured into stained acrylic canvases with the tints blending into each other. In 1973 he returned to an earlier way of painting using thickly applied pigments.

PASMORE, Victor Born Chelsham, England 1908, co-founder in 1937 of the Euston Road school, misty, delicate realistic work of great charm. In 1947 turned to abstract art, and in 1951 to constructions, many of them of a chunky nature.

PICABIA, Francis 1879-1953 Born Paris 1879, and died in Paris 1953. First one-man show 1905, and began painting abstract paintings shortly before World War 1, though later he turned to Surrealism.

PICASSO, Pablo Born Malaga, Spain 1881, died in Antibes 1973. Settled in Paris 1904, and with Braque invented Cubism. Picasso produced very little non-figurative work, but was a powerful influence on abstract artists through his pioneer work.

POLLOCK, Jackson Born Cody, Wyoming 1912, died East Hampton 1956. First one-man show 1946. The quintessential action painter, and many of his innovative techniques – such as spraying, dribbling and pouring – became established procedures. Pollock was very interested in the role of the unconscious in art.

POONS, Larry Born Tokyo 1937, though American. His innovative techniques include placing spots of colour against a rich background, and his art is essentially optical rather than geometric or organic.

REINHARDT, Ad Born Buffalo, New York 1913, died New York 1967. First one-man show 1944, and was a photographer in the US Marines. A subtle painter of geometrical abstracts, with rectangles hardly distinguishable from the background colour. His *Black on Black No 8* of 1953 harks back to the work of Malevich.

RILEY, Bridget Born London 1931. The most celebrated British practitioner of Op Art, first show 1962. She moved from black and white to·colour about 1965.

RODCHENKO, Alexander Born St Petersburg 1891, died Moscow 1956. Studied in Moscow 1915, much influenced by Cubism, and was an important figure in the new Union of Painters in Revolutionary Russia, becoming the first director of the Museum of Artistic Sculpture. Experimented with abstract painting with black on black paintings and red, blue, and yellow monochrome canvases, with constructions, typography, posters, advertisements, stage design, and photography. Returned to figurative painting 1935, before reverting to an abstract style in 1940.

ROTHKO, Mark Born Dvinsk, Russia 1903, died New York 1970. First one-man show 1933, his large paintings often feature just a few, sometimes merely two, roughly defined floating shapes, usually rectangular.

SCHWITTERS, Kurt Born Hanover 1887, died Ambleside, Cumbria 1948. Studied in Dresden, left Germany for Norway 1937, then to Britain in 1940 where he was interned. He began as an Expressionist, flirted with Surrealism, but is best known for his collages, very abstract in appearance if not in intention.

SERVRANCKX, Victor Born Diegem, Belgium 1897, died Vilvoorde, Belgium 1965. First one-man show 1917, much influenced by Leger in his neat formal paintings often on mechanical themes.

SOULANGES, Pierre Born in Rodez, France 1919. First show in 1946 with powerful abstracts, with the paint roughly applied in the manner known as gestural.

STÄEL, Nicolas de Born St Petersburg 1914, died Antibes 1955. After service in the French Foreign Legion, returned to Paris in 1943. One of the most subtle and stylish of abstract painters and a master of colour. His paintings consist of immaculately placed segments of paint, sometimes with still-life echoes.

STELLA, Frank Born Malden, Massachusetts 1936. First one-man show of shaped canvases – semicircular, quarter circle, fan – in 1960, usually covered with geometric figuration such as lines carefully following the outlines of the canvas.

STILL, Clyfford Born Grandin, North Dakota 1904. First one-man show 1943. Straightforward abstract paintings, often depicting jagged shapes.

TOBEY, Mark Born Centerville, Wisconsin 1890, died Basle 1976. Interested in Buddhism, and from 1930–7 a teacher at Dartington Hall, Devon. Tobey was an important early Abstract Expressionist, using softer colouring than Pollock and being far less vehement.

VASARELY, Victor Born Pécs, Hungary 1908. Moved to Paris 1930, worked as a commercial artist, turned to fine art 1944. A pioneer of Op Art, but he also painted geometrical abstractions featuring small repeated units.

INDEX

References to pictures appear in italics

Mellgrind
Owl lodge
1-800-
338-2800